Snapshots of San Diego:
SUN, SURF & SAND

Anita Yasuda

Schiffer Publishing Ltd

4880 Lower Valley Road Atglen, PA 19310

Published by Schiffer Publishing Ltd.
4880 Lower Valley Road
Atglen, PA 19310
Phone: (610) 593-1777; Fax: (610) 593-2002
E-mail: Info@schifferbooks.com

For the largest selection of fine reference books on this and related subjects, please visit our
web site at **www.schifferbooks.com**
We are always looking for people to write books on new and related subjects. If you have an
idea for a book please contact us at the above address.

This book may be purchased from the publisher.
Include $3.95 for shipping.
Please try your bookstore first.
You may write for a free catalog.

In Europe, Schiffer books are distributed by
Bushwood Books
6 Marksbury Ave.
Kew Gardens
Surrey TW9 4JF England
Phone: 44 (0) 20 8392-8585; Fax: 44 (0) 20 8392-9876
E-mail: info@bushwoodbooks.co.uk
Website: www.bushwoodbooks.co.uk
Free postage in the U.K., Europe; air mail at cost.

Copyright © 2008 by Anita Yasuda
Library of Congress Control Number: 2007938493

Designed by Ro Shillingford
Type set in Humanst521 BT

ISBN: 978- 0-7643-2804-6
Printed in China

Contents

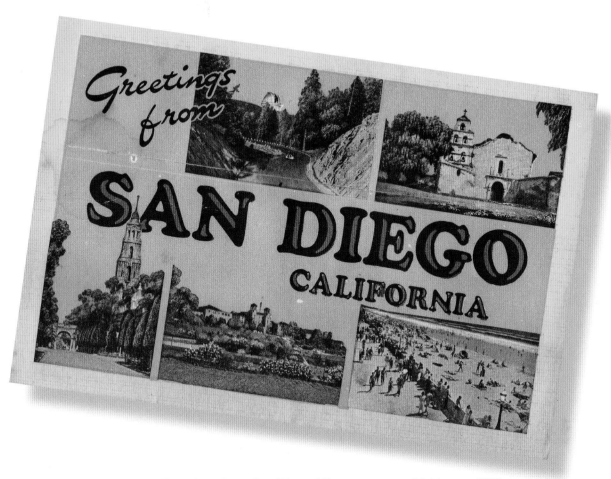

Greetings from San Diego. Vintage postcard folders, c.1950s.

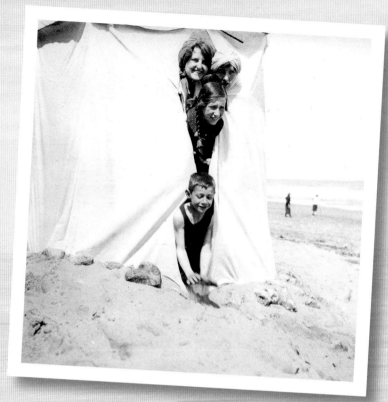

What fun! Playing hide and seek with the camera, this group of cheerful children peep out from a tent. With its warm Mediterranean-like climate and an arms length list of attractions it is little wonder that San Diego was ranked eighteenth "Most Fun U.S. City" in a survey conducted in 2003 by Cranium Inc. With events such as the San Diego/Del Mar Fair, Comic-con, Holiday Bowl and Poinsettia Bowl, San Diego's ranking will surely only increase. Vintage photograph, c.1920s.

Acknowledgements

The author is very grateful to an extremely patient eight-year-old who spent countless hours on San Diego's beaches. The eight-year-old is equally grateful to all the vendors who kept her full of ice-cream filled waffle cones with rainbow sprinkles, chocolate chips, and cookie crumble. And maybe the dentist is too!

San Diego is a dream city to live in, work in, visit and photograph. It is the hope of the author that you enjoy the warmth of San Diego as you turn the pages.

Introduction

Focus. Aim. Shoot. The click of a shutter immortalizes a moment in time. After months of letting your photos take up permanent residence on the computer's hard drive, a simple click brings them onto the screen. Blazing sun and hot sandy beaches are the stuff that memories are made of.

Snapshots have the power to transport us, as if we were in a wonderful time machine of H.G. Well's making. Could that be the scent of sunscreen coming from your monitor? In a flash you are humming the Beach Boy's classic 'Surfin' USA'. You are overcome with the urge to dig out your suitcase.

Now, picture this: A San Diego holiday, where the days seem endless and permanent residency on your beach blanket is possible. Perhaps you contemplate a new career as a sandcastle builder, shell collector, boardwalk cyclist, or relaxation consultant. What ever your choice, you can imagine yourself back in time.

The snapshots assembled in this book will take you on a virtual tour of six distinct beach areas in San Diego. See sand stone cliffs, foaming surf, and stroll pristine seashores and bustling boardwalks; witness as people play in the surf, snorkel amongst the Garibaldi, search for the tree in La Jolla Cove Park that's said to have inspired the art work of Dr. Seuss, and ride the coaster at Mission Beach.

And, when you think that you have seen all that San Diego can offer, strike out in a new direction. See 'The City across the Bay', Coronado, where the ghost of Kate Morgan is said to haunt the famed 'Del'; and Del Mar, immortalized by Bing Crosby in the song "Where the turf meets the surf"; experience the sunset in 'The Village By The Sea', Carlsbad—you might see a green flash.

Vintage San Diego travel advertisements, postcards and photographs from the early 1900s to the present extol the virtues of San Diego. Stepping foot on San Diego's sandy shores, Alonzo Erastus Horton, an influential San Diego real estate developer of the time, said, "I have been nearly all over the world and this is just the prettiest place for a city I ever saw."

Put on some sunscreen. Slap on a hat. Slip on your shoes… Your beach adventure begins. Check the compass — latitude 32.715N longitude 117.156W. You're in sunny San Diego.

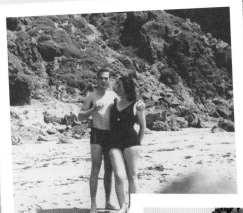

Say Cheese. Not just a strip of sand but a place to surf, sail, swim, play and try and have the best day of your life and if you don't succeed come back and try the next day. Vintage set of three photographs, c.1960s.

A couple hams it up for the camera on an undisclosed beach.

Endless Sun—San Diego averages an unbelievable 300 sunny days a year. This much good fortune surely must be shared!

5

Album One:

Destination San Diego

Sun! Sand! Surf! If a city had a lucky number San Diego's should be seven. Seven, as in the average daily temperature of a perfect seventy degrees—70 degrees! It's truly criminal! While in other parts of the United States people are schlepping out to local Home Depots to check out the latest selection of snow blowers and shovels, those lucky San Diegoites are gardening. Crowds flocking to malls aren't greeted with evergreens but with Christmas trees made out of stacked red poinsettias. Santa is probably sporting a tan. What could be the greatest San Diegoites hardship in the winter, perhaps a lawn sprinkler that might be frozen in the morning?

And, while residents in other parts of the United States are dealing with stifling summer humidity, a San Diego summer is practically humidity free. Summer time highs average a perfect seventy-five degrees. Is it really any wonder that San Diego is known as 'The Jewel'? It is the only city listed by *Holiday Magazine* as the destination with perfect weather. Staying in San Diego and watching perfect sunrise after sunset, you may be convinced, as the early town boosters of San Diego were, that this city is indeed 'heaven on earth.'

Over the years San Diego has been given many nicknames: '*The Place Where California Began*', '*The First Great City of the First Century*' and '*Plymouth Rock of the West Coast*'. San Diego's history dates back to 20,000 BC when it was first inhabited by native tribes. It was not until the Sixteenth Century that the first European, Juan Rodriguez Cabrillo, sailed into San Diego Bay. It was September 18, 1542, and he named his discovery San Miguel in honor of the Feast Day of San Miguel. Sixty years later the Spanish explorer Sebastian Vizcaino renamed the area in honor of the Fifteenth Century Saint, San Diego de Alcala.

The Cabrillo National Monument. The statue shows Cabrillo looking out over the bay that he first sailed into on September 28, 1542. Alvaro De Bree, a well-known Portuguese sculptor, created the statue, which was to be given to the State of California for the San Francisco World Fair but, as it was late, a copy was put up in its place. Senator Ed Fletcher of San Diego arranged for the original statue to be moved to San Diego. Vintage postcard c.1920s.

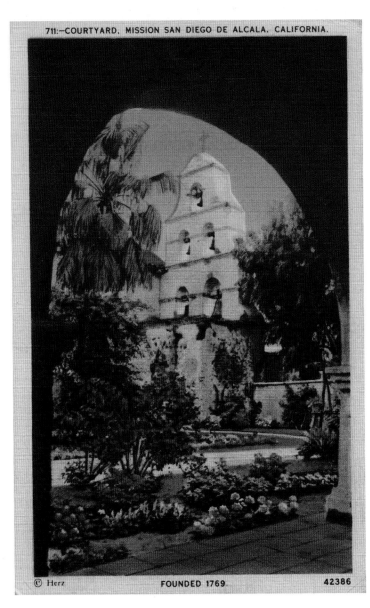

711:—COURTYARD. MISSION SAN DIEGO DE ALCALA. CALIFORNIA.

© Herz FOUNDED 1769. 42386

Mission San Diego de Alcala is a National Historic landmark, California Historic landmark and a City of San Diego Historic landmark. Vintage postcard c.1950s.

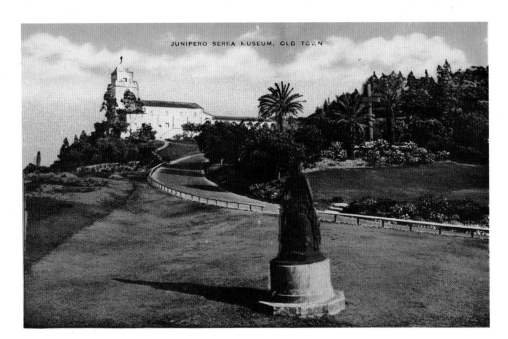

JUNIPERO SERRA MUSEUM, OLD TOWN

The Junipero Serra Museum was constructed in 1929. It is located on Presidio Hill in Old Town Historic Park where California's first mission began. Vintage postcard c.1950s.

San Diego has been the site of many important firsts—it was the site of the first Spanish contact, the first European settlement on the west coast of the United States and the first mission in California. Father Junipero Serra established the Mission San Diego de Alcala in 1769. Later there would be twenty-one missions in total reaching all the way to Northern California.

Recent nicknames for San Diego have been inspired by the present. San Diego's former mayor and former Governor of California, Pete Wilson, dubbed it *'America's Finest City'*. San Diego's sporty residents prompted *Sports Illustrated* in 2003 to name it *'America's Fittest City.'* The business of sports is San Diego's fourth largest industry. With such glowing endorsements, it is no surprise that San Diego is the seventh largest city in the nation.

The next seven for San Diego is in the seventy miles of beaches. With thirty-nine beaches in San Diego County, you could feasibly visit a different beach each day for a month, starting at Beacon's Beach and working alphabetically down the list until you ended at Windansea. You would have quite the tan, but wouldn't it be worth it?

Family Fun Magazine once described San Diego as "the most family friendly city in the western region of the U.S.", which brings us to our last seven—the twenty-seven million tourists who came to San Diego in 2006.

See You In San Diego!

Whose glum? This unfortunate family seems to have landed on a beach not in San Diego. If they had, of course they would have been smiling. Vintage photograph c.1900s.

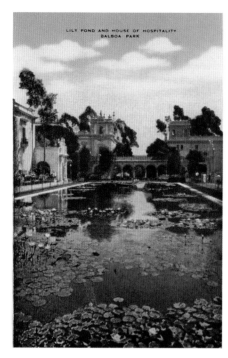

The lily pond was built specifically for the 1915-16 exposition. Vintage postcard c.1950s.

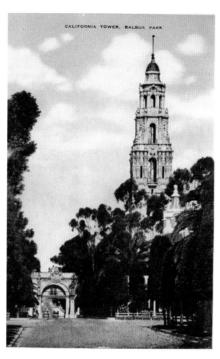

The California Tower measuring 200m high is the focal point of Balboa Park. Today the Museum of Man is located here. Plaza De Panama, Vintage postcard c.1950s.

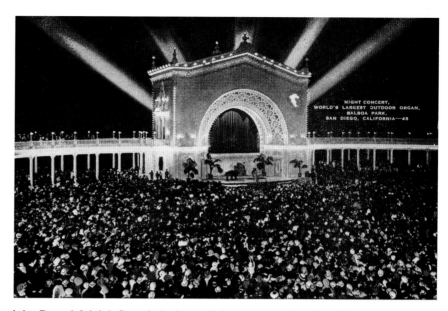

John D. and Adolph Spreckels donated the organ to the City of San Diego for the Panama-California Exposition. They paid $33,500 for the organ and $66,500 for the pavilion. The organ is the largest outdoor organ in the world with 4,500 pipes. The Spreckels organ is still in use. Free Sunday concerts are held year round with extra performances being added in the summer. Vintage postcard c.1950s.

The development of tourism in San Diego can be traced through travel advertisements from the early 1900s to the present day. When San Diego played host to the Panama-California Exposition in 1915, there wasn't even a visitor's bureau. Promoting San Diego was left to the organizers. Low rail costs, plentiful hotel accommodations and interesting displays were highlighted. Visitors to the fair could ride in wicker, motorized carts akin to golf carts and tour the park in comfort. From the exclusive vantage point of their 'electriquette', guests were treated to marching bands, concerts on the largest outdoor organ, beautiful gardens, Mayan Indian history displays in the California building and even a Native American Indian replica village where it was noted by a critic of the time that the primitive homes contained "...steamer trunks and kitchen clocks." On the shocking side, especially for the early 1900s there was a nudist display. Of course it was protested but perhaps not for the reasons that first come to mind. The exposition nudists were protested because the girls were "...neither truly nude nor beautiful."[2]

The publicity generated from the fair put San Diego on the map. The 1,400-acre 'City Park' created just for the exposition is still enjoyed by countless San Diegans and visitors. Today it is known as Balboa Park, the result of a citywide naming contest in 1910.[3] Balboa Park was named for Vasco Nunez de Balboa, the first European in the New World to have reached the Pacific Ocean.

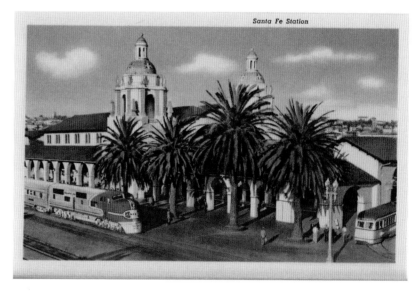

Santa Fe Station opened in 1915, just in time for the Panama Pacific Exposition. It was built on the spot of the original 1887 depot. It is on the National Registrar of Historic Places. The station is still in use today. Vintage postcard c.1950s.

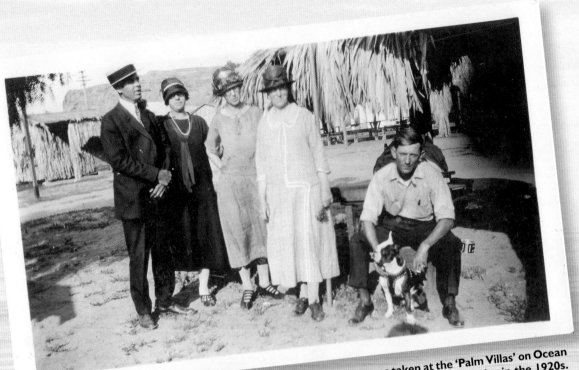

A vintage 1925 black and white tourist camp photograph. This shot was taken at the 'Palm Villas' on Ocean Boulevard. Perhaps not a 'villa' by today's standards, but tourist camps were very popular in the 1920s. The long dresses, cloche hats and woolen tights must have been stifling in the summer heat, but perhaps the allure of 'living' on the beach made up for any discomfort.

Town Boosters

The success of the 1915 exposition directly led to the founding of the San Diego-California Club in 1919 by a local realtor, O.E. Cotton. The San Diego-California Club was the first of its kind to promote San Diego as a tourist destination. The advertisements put out by this group promoted a healthy lifestyle only attainable in San Diego; pictures of presumably healthy children sitting on sandy beaches gaze back at the viewer. Innovative for the time there were clip-out forms that could be mailed in for more information. The amount of advertising from the 1920s is quite remarkable; two markets were tapped, the prospective resident and the traveler.

In the 30s Joseph E. Dryer formed the Heaven and Earth Club. The club's goal was to promote the benefits of life in San Diego and encourage people to come and settle there. Locals were encouraged to send postcards to their relatives. Architectural structures built for the Panama-Exposition, bathers at the Cove-La Jolla, Sunday afternoon at Ocean Beach, San Diego missions, Point Loma, Sunset Cliffs and the Coronado were all popular subject matters of postcards from the 1920s. The beaches of San Diego, the Spanish architecture in Balboa Park and the historic missions must have seemed exotic to friends and family in other states.

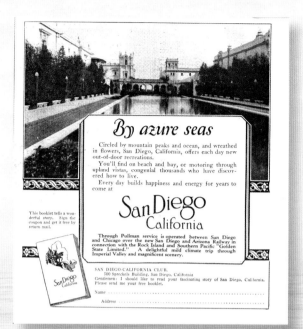

'You will find healthful comfort...' A vintage 1921 San Diego black and white travel advertisement.

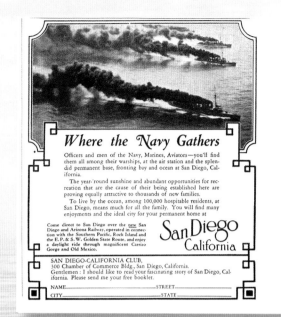

'Circled by mountain peaks and oceans' reads this ad by the San Diego-California Club. A vintage 1921 San Diego black and white travel advertisement.

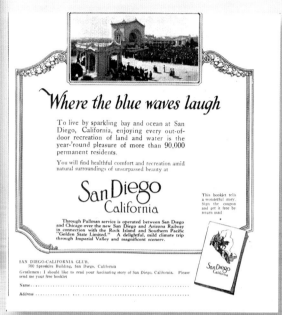

'...the ideal city for your permanent home at San Diego California.' A vintage 1923 San Diego black and white travel advertisement.

The advertisements of the 1920s promised a Twentieth Century life filled with beauty and romance. Ads overflowed with flowery prose: ocean sunsets, garlanded streets, and daily concerts in the parks. A great slogan from this time, one current residents wish were still true, was that 'with a moderate competence you can live easily in SD'—that alone must have sold the city to many an East Coaster.

1920s Advertising Slogans

- "All year you can live outdoors by a blue ocean in California's loveliest city"
- "Miles of White Beaches"
- "Where the Navy Gathers"
- "By Azure Sea - Everyday builds happiness and energy for years to come"
- "Where the blue waves laugh"
- "On The Blue Bay Where California Began"
- "A City Built For You"
- "Everyday's a day for golf and motor trips"

SunLaze

From 1935 to 1936 San Diego hosted a second World's Fair, the California-Pacific Exposition, that gave San Diego widespread publicity. With the onset of World War II, San Diego experienced a period of enormous growth, as it became the center for the Pacific fleet.

A 1944 San Diego souvenir booklet offers this tongue twisting phrase — 'beaches beckon to bathers and baskers.' This booklet was not aimed at tourists but at war workers, servicemen and women on leave. Servicemen saw captions such as "Some of the boys returning from the African campaign will recognize the animals pictured here." Unintentionally humorous, the picture featured is that of an elephant.

After the war in 1946 the Heaven and Earth Club was absorbed into the San Diego Visitors Bureau. The proximity of San Diego to Old Mexico - only thirty minutes away - and the desert were highlights of these campaigns. By the 1950s the ads became more exciting. San Diego equaled adventure in the form of deep-sea fishing. Sub captions for the adventure ads included the line 'conquest in San Diego—Man over fish.' The man is shown proudly holding a speared fish while his wife sits passively on a nearby rock watching the action. Adventure and excitement it would seem were only male pastimes in the 50s. Print ads from the 1950s, like the ones of the 1940s, tried to lure visitors with San Diego's close locale to an exotic and interesting foreign land, Mexico!

"Mention the Geographic—It identifies you."

1930s - 1950s Advertising Slogans

- "Sun laze in the winter mildness of San Diego"
- "This Winter Get All 3"
- "Come to life in San Diego—America's only International Playground"
- "I fed a bird with a beak this long"
- "Where California & Mexico Meet"

Ads such as these are highly sought after by collectors. This advertisement was produced to promote the 400th anniversary celebration of Cabrillo's landing in San Diego. Many of the festivities were cancelled including the dedication of the Cabrillo statue due to World War II. Instead a small commemorative ceremony was held with members from the Portuguese community, military and city officials. The annual Cabrillo festival is held during the last week of September in San Diego. The festival site is the Cabrillo National Monument and the festival runs for one week; this year, 2007, will be the 44th annual Cabrillo Festival. *A vintage 1942 San Diego black and white travel advertisement.*

Amusements

Three of San Diego's premier attractions opened between 1960 and 1970, helping to boost tourism: Sea World in 1964 with its seawater aquariums, Old Town State Historic Park in 1968, and the popular Wild Animal Park in 1972. San Diego's rich heritage and its premier visitor attractions were both highlighted in full-page glossy ads. Mission Bay Aquatic Park, Seaworld, the San Diego Zoo, Palomar Observatory and historic sites like San Diego de Alcala were showcased. San Diego's Mexican history was highlighted with this slogan, "…a vacation in the best of California crowded with the color of two countries".

The 1960s also saw the visitor bureau change its name yet again to 'The San Diego Convention & Visitors Bureau.'

Renewal

The 1980s saw a much needed renewal in downtown San Diego. The end of the 1980s saw San Diego becoming a cruise ship port and by 2003 over 300,000 passengers were processed, double the number from 1999. Ads aimed at the high-end traveler listed in check mark fashion activities such as golfing, tennis and wine tasting.

Today

Advertising has come full circle in recent years, now aimed at the residents of San Diego. In 2000 San Diegans were encouraged to come out and rediscover their city. Why get on a plane or train when you live in San Diego, the consumer was asked. With seventy miles of beaches, one-of-a kind amusement parks, incredible museums and galleries, San Diego is a must see city for both tourists and residents.

1960s - 1970s Advertising Slogans

- "San Diego is Excitement"
- "Excitement-The best of California where there is more to see and do."
- "San Diego Ole!"

1980s - 1990s Advertising Slogans

- 'What can you do every day of the year in San Diego?'
- 'If it swims, roars, dives, slithers, flips, snarls or splashes you'll find it in San Diego—San Diego feels good all over.'

2000s Advertising Slogans

- "Be a tourist in your own backyard!"
- "365 days of ahhhhhhh…"

Album Two:

Torrey Pines State Beach and Reserve

Without a busy boardwalk or any buildings, Torrey Pines Beach seems far removed from civilization and yet downtown La Jolla is just a few minutes away and Highway 101 is at your back. Stand at the base of the sandstone cliffs and look way up, 300 feet up. You might see a sky full of colorful para-gliders. The Torrey Pines Gliderport is situated on the cliff. For a completely unique view of La Jolla, is there anything better than soaring high above the Pacific? The members of the glider club would probably tell you no.

The cliff is also home to a historic 1923 pueblo-style house, which serves as the Torrey Pines State Reserve's visitor center. There are informative exhibits on the natural and cultural history of the reserve. The broken cliffs, deep ravines, lagoons and wetlands on the 2,000 preserved acres present a picture of San Diego before it was developed. The hiking trail along the bluff rewards the visitor with sweeping views of the coastline. You will see the tip of La Jolla shimmering in one direction and Carlsbad in the other. The guided tours on the weekends will have you knowing your Indian paintbrush from your Golden Yarrow in no time. Whether you enjoy swimming, surfing or hiking along its eight miles of trails you will thank the individuals who had the foresight to preserve the area.

A sunset on the Torrey Pines bluff clearly demonstrates why early Town Boosters promoted San Diego as 'Heaven on Earth.' Vintage postcard, c.1950s.

Sunset - Torrey Pines. 28

What's in a Name?

Torrey Pines State Beach is named for the rarest pine in North America, the Torrey Pine. Its twisted limbs are battered by the wind into unusual shapes. The largest number of Torrey Pines grows in this coastal area of San Diego.

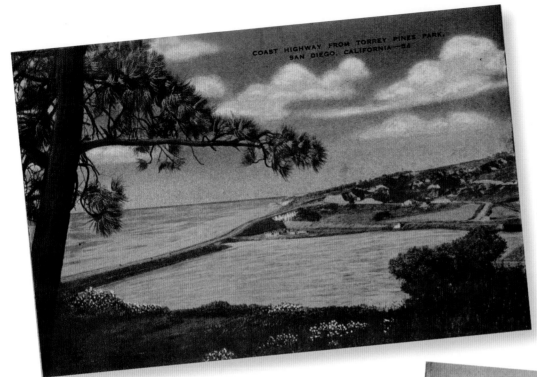

Coast Highway from Torrey Pines Park.
Vintage postcard, c.1950s.

Torrey Pines Park.
Vintage postcard, c.1950s.

Welcome to La Jolla. Vintage postcard, c.1950s.

La Jolla

92037, no this isn't the name of another television show but the zip code for La Jolla. Even though its part of San Diego, La Jolla is a world unto itself complete with it's own zip code. Mediterranean luxury, Hollywood glamour and Southern California appeal permeate the air—you'd half expect Greta Garbo to emerge from the stunning landmark hotel, the La Valencia.

Besides the galleries and high end shopping on Prospect Street - where it is easy to wile away a few hours - La Jolla is also home to world-renowned institutions. The Scripps Institution of Oceanography, Scripps Memorial Hospital & Medical Research Center, the University of California at San Diego, and the Museum of Contemporary Art, created in 1941 from Ellen Browning Scripps 1915 residence, are all here. After you have seen the jellyfish at the aquarium or marveled at Nancy Rubin's 'Pleasure Point' boat sculpture high atop the museum of modern art, walk towards Ocean Boulevard. There are thirteen miles of magnificent coastline to explore in La Jolla.

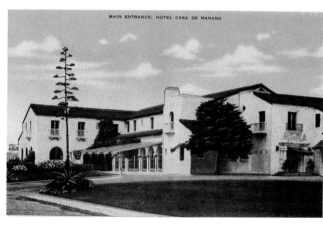

Hotel Casa de Manana opened in 1924 as a luxury hotel and vacation destination. Today it is a retirement community along Coast Boulevard. Vintage postcard, c.1950s.

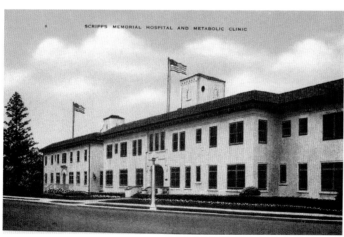

Scripps Memorial Hospital & Metabolic Clinic. The original building, completed in 1910, was designed by architect Irving Gill. The building is a national historic landmark and the oldest oceanography laboratory building in the United States. The building that Gill designed is now home to the Scripps Graduate Department.
Vintage postcard, c.1950s.

What's in a Name?

La Jolla is likely from the Native American word "woholle" meaning hole in the mountain or, perhaps, referring to the seven caves along the cliffs of La Jolla. The origin of the name isn't without controversy. There are others who believe the name comes from the Spanish word la joya meaning jewel. Both parties would surely agree with Frank T. Botsford, a real estate developer who simply declared the area 'magnificent.' [4]

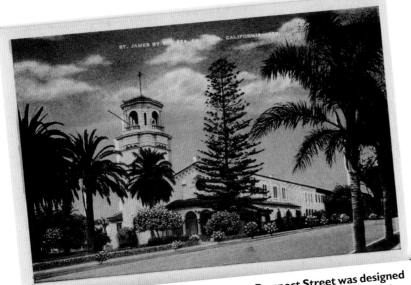

St. James By The Sea Episcopalian church on Prospect Street was designed by architect Irving Gill. If you walk along Prospect Street, you'll see a few of Gill's architectural gems. Vintage postcard, c.1950s.

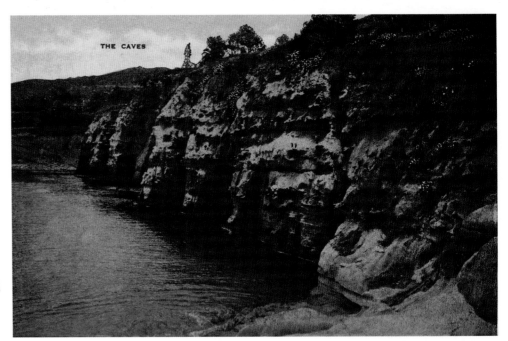

The seven caves of La Jolla. The largest cave is called Sunny Jim after a 1920s cereal mascot it was said to resemble. The cave is accessible by land through 'The Cave Store' and down 145 steps. Vintage postcard, c.1950s.

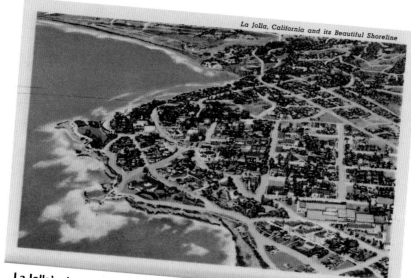

La Jolla's shoreline. Vintage postcard, c.1950s.

What Can You Buy For a Dollar?

Back in the 1880s you could buy an acre of land in La Jolla for roughly $1.25. Today that would be the equivalent to a million dollars. Obviously it is either time to start working on your DeLorean time machine or set up a lawn chair on Ocean Boulevard and enjoy the ocean view for free

La Jolla Cove

A flight of concrete stairs leads you down to a small sandy beach simply known as 'The Cove.' It has been an historic spot for swimming. The swimming area extends half a mile out. It is the site of several yearly swimming races such as the La Jolla Rough Water Swim, a three-mile swim to the tip of Scripps Pier and back. The name of the race says it all with some swimmers having to be rescued from the three to six-foot high seas.

If wrestling waves is not for you, a less strenuous experience - but still extremely rewarding - is exploring tidal pools. At low tide, the clear pools are alive with hermit crabs, sea snails, sea urchins and brittle stars.

Alligators?

An alligator in the cove? Surely there couldn't be. Now before you think you are in the Florida Everglades, the alligator in question here is in fact a rock formation on the western tip of La Jolla Cove called Alligator Head Point. The subject of many a postcard from the 1910s, today the snout of the 'gator has been reduced to rubble as a result of erosion.

The small cottages, which once lined the road by the Cove, have been replaced for the most part by hotels, condos and vacation housing; the exceptions to this are two red cottages in a state of disrepair. Vintage postcard, c.1950s.

In this shot the rock formation known as Alligator head is visible. Alligator Head was a piece of land that used to jut out into the ocean. It was the subject of many postcards throughout the early 1900s. It marks the northwest boundary of the reserve. Vintage postcard, c.1950s.

19

PARK, LA JOLLA

At the top of the cliff is The Ellen Browning Scripps Memorial Park, formerly known as 'The Park'. It is a beautiful place for setting down a picnic blanket and enjoying the view. You might even spy a wedding or a yoga class on its manicured lawns. Next time you are in the park see if the *Cat in the Hat* or *Green Eggs and Ham* comes to mind. Why? A tall scrubby tree located here is said to have inspired, Dr. Seuss's, Theodor Geisel, illustrations. Be certain to stay long enough to catch the sunset from this special beach.

The Park is now known as the Ellen Browning Scripps Park. The Washington Palms seen in this postcard were planted in 1904. Vintage postcard, c.1950s.

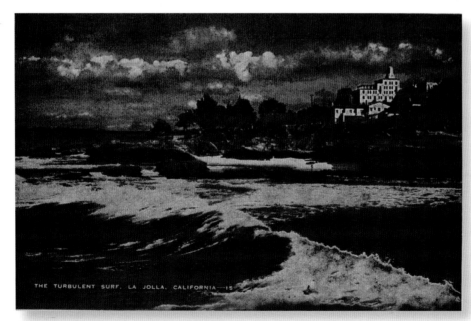

THE TURBULENT SURF, LA JOLLA, CALIFORNIA — 15

Evening surf. Vintage postcard, c.1950s.

La Jolla Shores

La Jolla Shores is a sandy beach about one mile long. This stretch of beach is alive with surfers, scuba divers, picnickers and eager day-campers enjoying the gentle waves. Dolphins also like the shores so keep your eyes peeled when you're out swimming.

La Jolla Shores has separate areas for swimming and surfing. Many surf schools run such as Surf Sister. It's hard to miss their brightly colored boards and eager students lined up on the west side of the beach. If you can swim, you can sign on for a lesson. Who knows, surfing might be your undiscovered talent.

After spending a few hours at the La Jolla Shores, you may think that you've seen it all, but you haven't. There are in fact two parks, the one above ground and the one beneath the ocean; the La Jolla Underwater Park and Ecological Reserve is popular with scuba divers. Suit up, join a class and you'll see black sea bass, scorpion fish and other underwater creatures. At the northern end of the beach is Scripps Pier. The Scripps Institute of Oceanography is on the bluff.

Kellogg Park

Kellogg Park is located behind the main lifeguard station. It's a small children's park with swings and climbing equipment conveniently located off the boardwalk. Florence Scripps Kellogg donated the seven-acre park to the City of San Diego in 1951.

Kellogg Park is a beautiful grassy park right at La Jolla Shores. The park is landscaped with towering palms and dotted with picnic tables. The sandy playground area is complete with climbing apparatus perfect for small children.

Tall palms along the wide cement boardwalk. Early morning walkers, joggers and even roller bladers enjoy the clean air. Florence Scripps Kellogg donated this piece of land in memory of her husband in 1951.

Children's park. Climbing structures, swings and even a pulley makes this a great spot for kids.

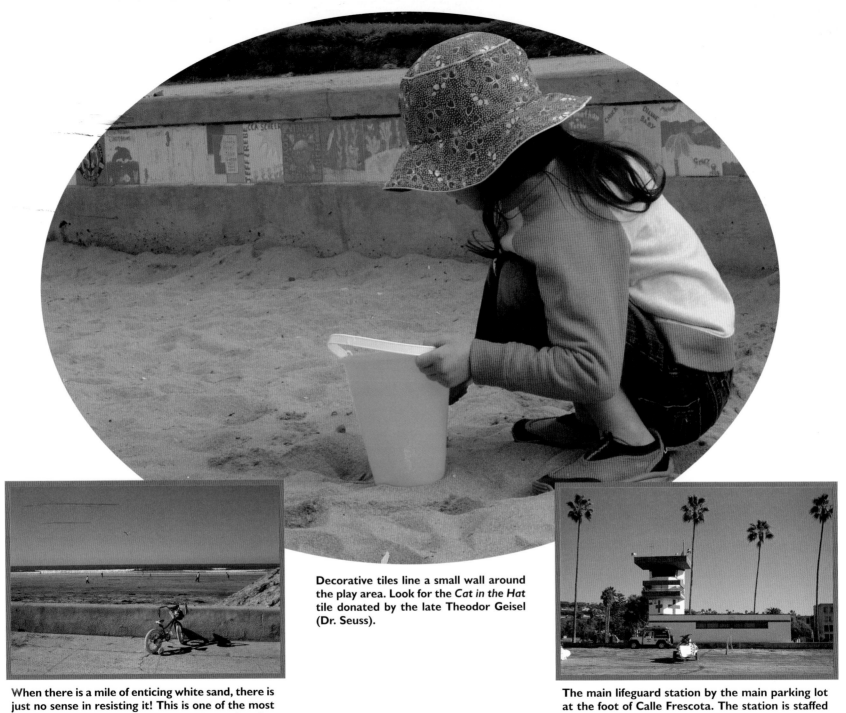

Decorative tiles line a small wall around the play area. Look for the *Cat in the Hat* tile donated by the late Theodor Geisel (Dr. Seuss).

When there is a mile of enticing white sand, there is just no sense in resisting it! This is one of the most popular spots along the coast and safest swimming areas.

The main lifeguard station by the main parking lot at the foot of Calle Frescota. The station is staffed from 9 a.m. to near dusk.

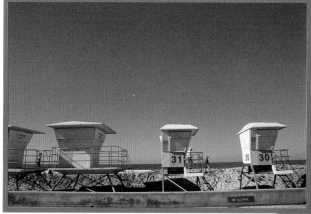

Lifeguard huts closed for the winter. You might be tempted to think that the beach is always so peaceful, but this is only the case during the winter months. Of course, with San Diego now hosting two college bowl games, the Poinsettia Bowl and the Holiday Bowl, tourist traffic has been picking up during the month of December.

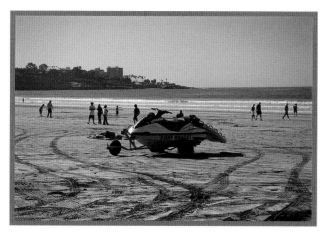

A rescue vehicle. San Diego lifeguards perform roughly 5,000 to 7,000 rescues per year.

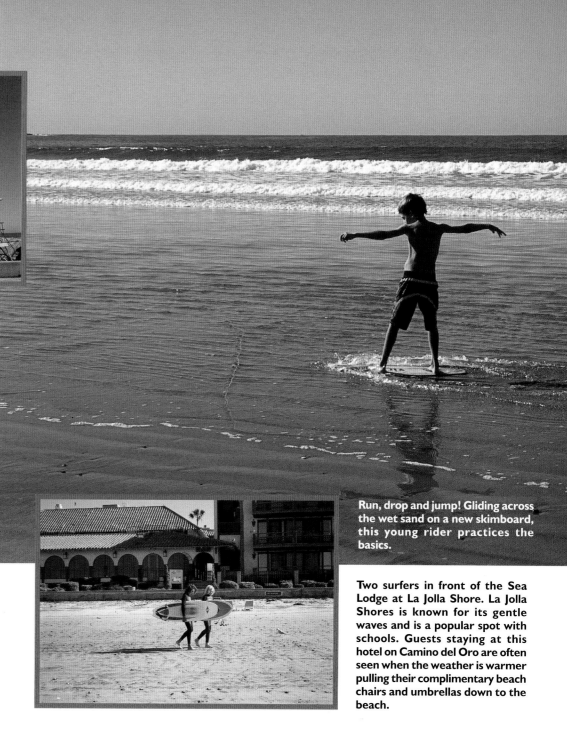

Run, drop and jump! Gliding across the wet sand on a new skimboard, this young rider practices the basics.

Two surfers in front of the Sea Lodge at La Jolla Shore. La Jolla Shores is known for its gentle waves and is a popular spot with schools. Guests staying at this hotel on Camino del Oro are often seen when the weather is warmer pulling their complimentary beach chairs and umbrellas down to the beach.

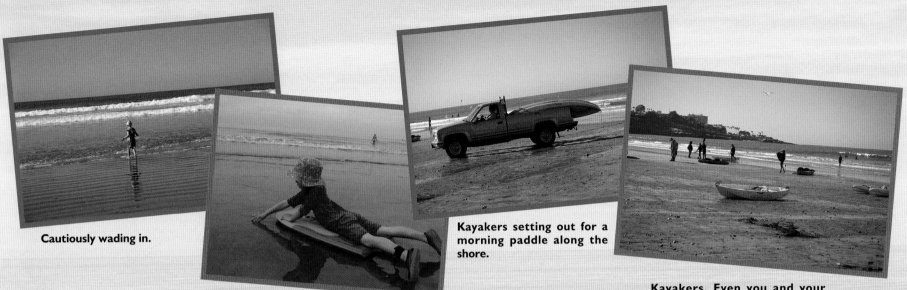

Cautiously wading in.

Waiting for the waves. La Jolla Shores is not known for its big waves, but at this rate this tiny boogie boarder will have to wait quite awhile to ride anything!

Kayakers setting out for a morning paddle along the shore.

Kayakers. Even you and your pooch can go along on a kayaking tour! South of this area are the famous 'Seven Caves'.

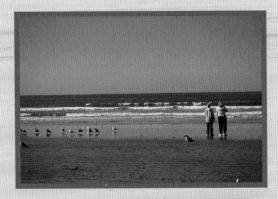

Pausing to take in the scenery along with some shore gulls. The mile long sand beach is adjacent to a residential area. How lucky would it be to stroll these waters on a daily basis. For more of a workout, leave the beach and head up hill to walk the Coast Walk pathway.

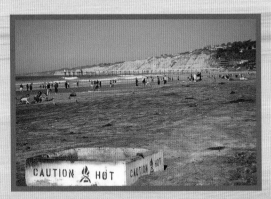

From one of the barbeque pits looking north towards Scripps Institution of Oceanography and Scripps Pier.

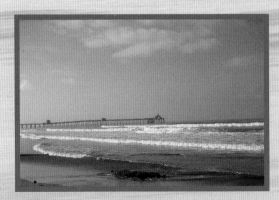

The Scripps Pier was first built in 1915 and later rebuilt in 1987 as a research pier stretching out some 1,090 feet. It is occasionally open to the public for educational walks and lectures by aquarium naturalists from the Birch Aquarium.

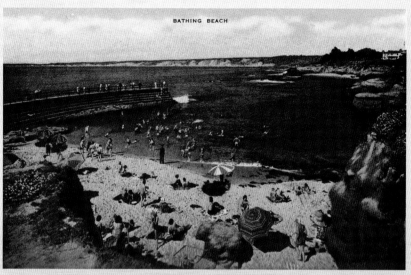

In the 1920s Ellen Browning Scripps began discussions with city engineer H.N. Savage for the building of a breakwater. Today it is off limits to bathers, but you will enjoy seeing the sea lions and seals. Vintage postcard, c.1950s.

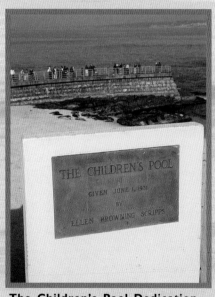

The Children's Pool Dedication plaque with the water break in the distance. The Children's Pool is also known as the Casa.

Children's Pool

The pool is a short walk from the main shopping streets of La Jolla. At Coast Boulevard and Jenner Street, this small beach is partially protected by a seawall. Though originally created as a fully protected swimming area, harbor seals had other ideas. The breakwater created an excellent habitat for seals, swimming in the water, sunning on the rocks or the sandy beach. This little beach is worth visiting as it provides a great opportunity to observe harbor seals in their natural habitat.

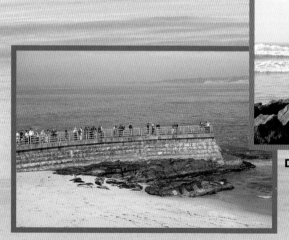

It's possible to walk along a stone pier out into the sea. It's a great vantage point for viewing the seals. The reserve for seals and sea lions is just one hundred yards offshore.

Down on the beach.

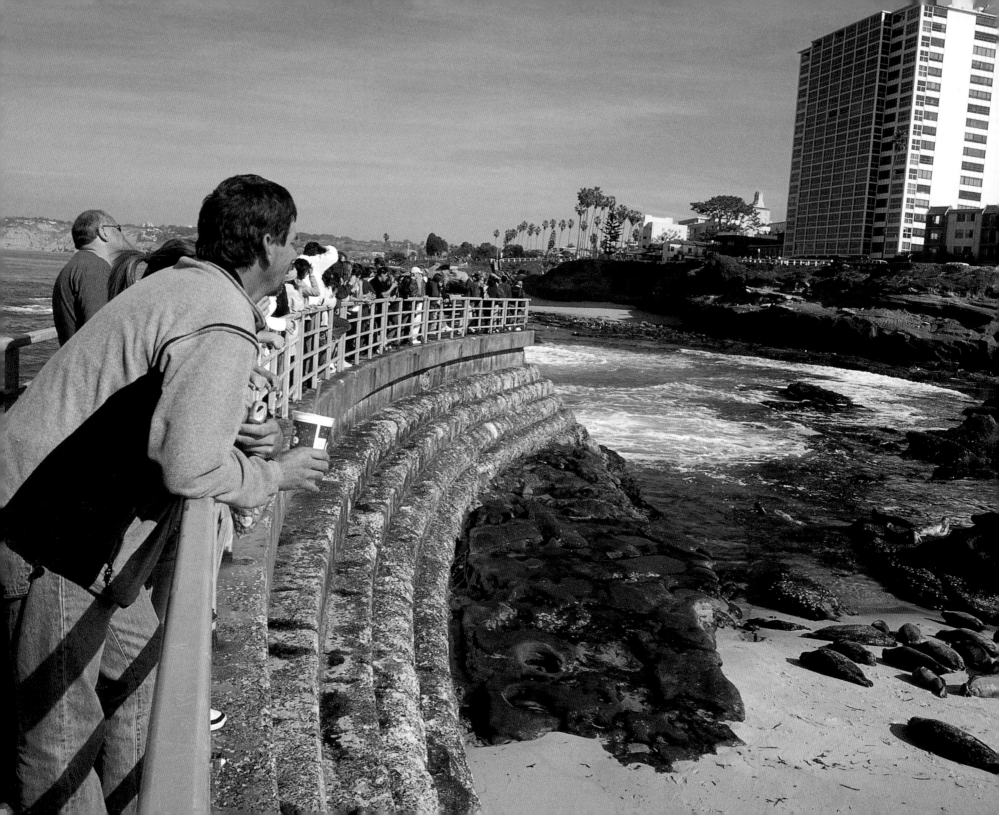

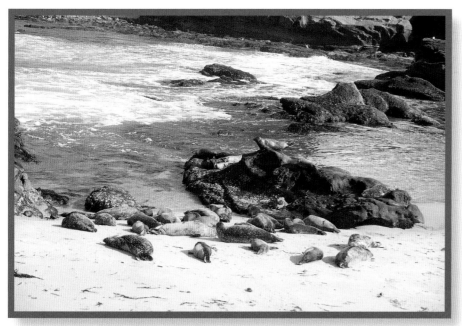

Seals have found this spot, among the rocks, to be the perfect home.

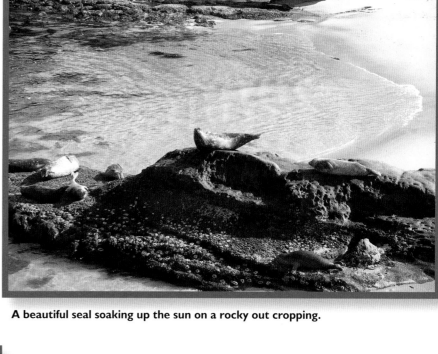

A beautiful seal soaking up the sun on a rocky out cropping.

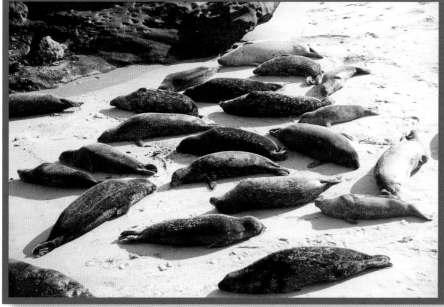

Seals and sand. Today, seals are at the center of controversy; the Marine Mammal Protection Act protects harbor seals, but there is a movement to have the seals removed so that the beach can again be used as a swimming beach. This issue will likely not be resolved soon or easily.

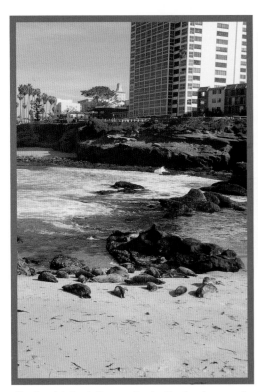

Seals with La Jolla condos in the background.

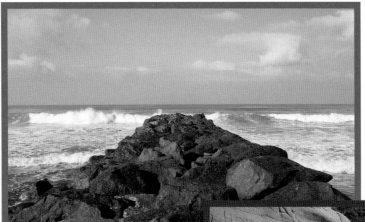

The pounding surf slowly chisels away at the rocks.

Not content to just take home memories of a great day on the beach, some have decided to leave a permanent reminder of themselves behind.

The rocky shoreline.

More small beaches

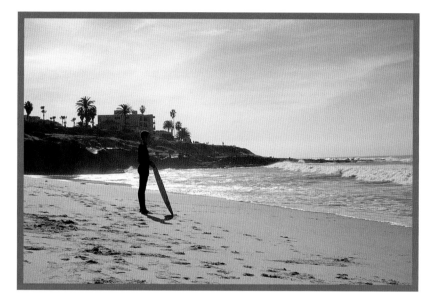

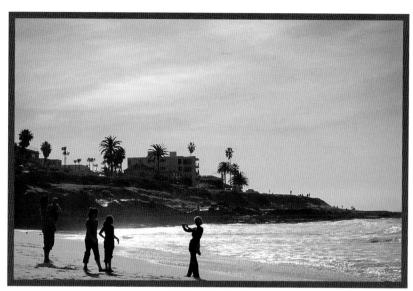

Remembering the holiday, a family takes a group picture.

There are many more small beaches in La Jolla such as People's Wall and Marine Street Beach. Both beaches are good for skimboarding. Here a rider sizes up the waves.

Riding the waves.

The surf rolling in over the shallow rocky bottom.

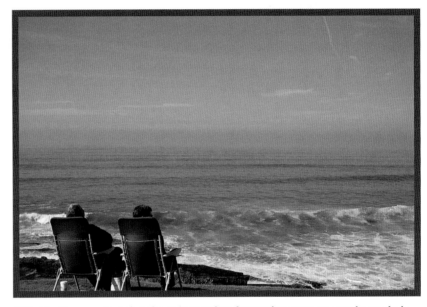

What better way to enjoy the scenery than by setting up your own lawn chair. Tourism is the third largest industry in San Diego, behind manufacturing and the military. With vistas like this, it's little wonder that in 2007 an estimated 28.4 million people will visit San Diego County.

Taking in the view.

Windansea

Come... let's play a game of word association. What is the first word that comes to mind when you hear the word 'takeoff'? Is it 'airplane'? How about 'carving'? Is it Thanksgiving? If so, you probably aren't too familiar with surfing as takeoff and carving are basic surfing maneuvers. For diehard surfers, Windansea is a legendary place with waves as high as six to eight feet. The waves attract the most skilled surfers.

If entering the X Games surfing competition is not one of your lifelong dreams, Windansea is a spectacular place to visit for the scenery alone. A relaxed atmosphere prevails especially during the winter months as locals stroll down to the couple of benches above the rocks and happily eat their breakfast.

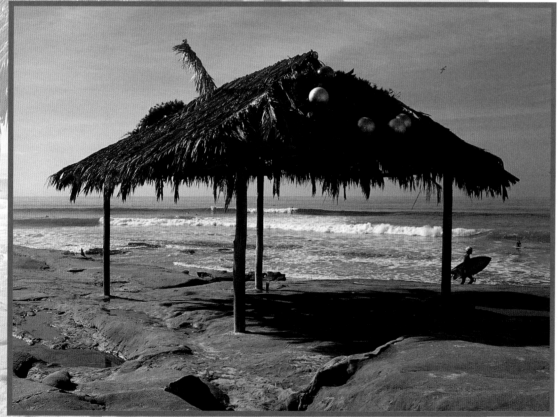

The Windansea hut was built in 1946 by local surfer legends Woody Ekstrom, Fred Kenyon and Don Okey.

What's in a Name?

Windansea takes its name from a hotel of the same name, which burned down in the 1940s.

Homes and Gates

The streets are lined with palatial homes,
but the odd white clapboard remains.

A quaint cottage with an electrifying cobalt blue door. Modest cottages that once stood in this area have slowly been replaced by multimillion-dollar homes. The movement to declare some homes as historic landmarks seems to be losing out to McMansions.

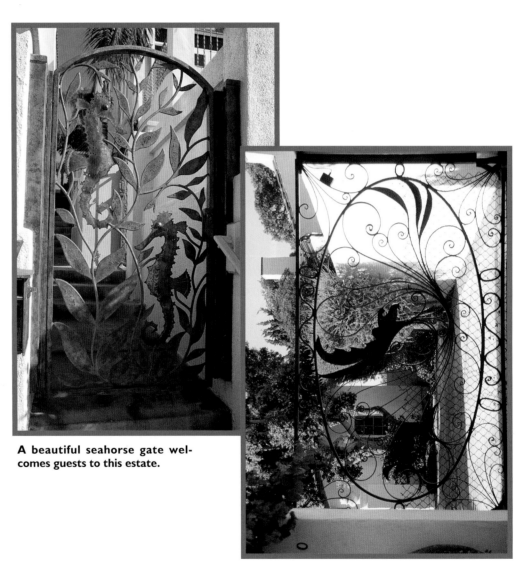

A beautiful seahorse gate welcomes guests to this estate.

Across the street is another fine example of an aquatic theme gate with a Mermaid.

A wildflower wall mural beautifies this otherwise drab concrete wall.

A gate reminiscent of the one described in the book *The Secret Garden*. There is something mysterious about the way it fits just so into the hedgerow.

There is never a chance for a white Christmas in La Jolla, but a snowflake can still adorn a hedge. This special Californian snow is the best kind as it never requires shoveling.

La Jolla Resources

When here, be sure to visit Scripps Aquarium to see the wonderful collection of rare fish and native California fish. There is a shark nursery where it is possible to touch a small nurse shark! Tidal pool exhibits give visitors a chance to touch sea cucumbers, sea stars and other tidal pool dwellers. Helpful docents (tour guides) are always ready to answer questions.

- *Birch Aquarium at Scripps*
 http://aquarium.ucsd.edu/
- *La Jolla Visitor Center*
 619-236-1212
- *La Jolla Historical Society*
 www.lajolla.org
- *La Jolla*
 www.lajollabythesea.com
- *La Jolla Surfing*
 www.lajollasurf.org
- *The Caves, La Jolla -- a draw for*
 tourists since the early 1900s.
 www.cavestore.com
- *Torrey Pines*
 www.torreypines.com

A Jellyfish.

A Leafy Seadragon.

There is so much to see at the aquarium that it will have your children saying wow!

A tide pool.

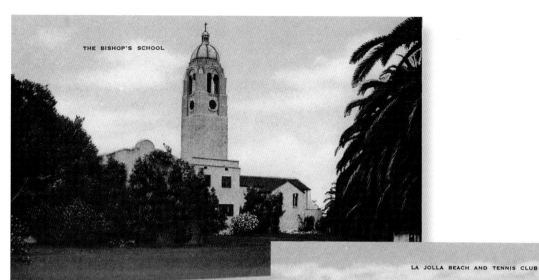

The Bishop's School was founded in 1909. Ellen and Virginia Scripps were generous donors to the school, which is still in use today. The tower, which you see in the postcard, is not there today due to remodeling work completed in the 1930s. The school was designed by Irving Gill. Vintage postcard, c.1950s.

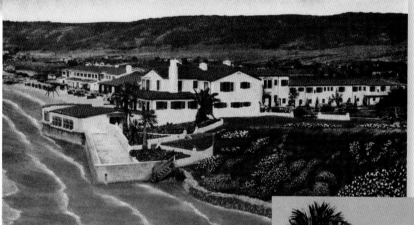

La Jolla Beach & Tennis Club opened in 1935 as a private social club. Developer Frederick William Kellogg bought the land in 1935. As of 2005 it was still owned by the Kellogg family. Vintage postcard, c.1950s.

The Art Center is now known as The Museum of Contemporary Art. The oldest part of the museum was built in 1915 and designed by architect Irving Gill, who was a pioneer of modern design. Vintage postcard, c.1950s.

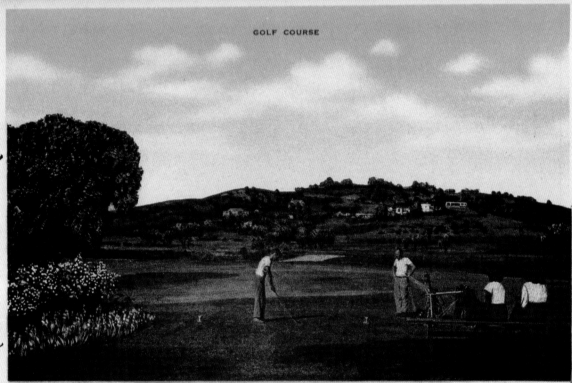

GOLF COURSE

Torrey Pines Golf Center. Before it was a golfing center, it was a military training center called Camp Callan. In 1956, one hundred acres of the camp was set aside for the construction of a public golf course. The Torrey Pines Golf Course is the site of the Buick Invitational. Vintage postcard, c.1950s.

After your exit from the Coast Highway there is parking right by the beach. A rocky descent leads you to a spectacular beach.

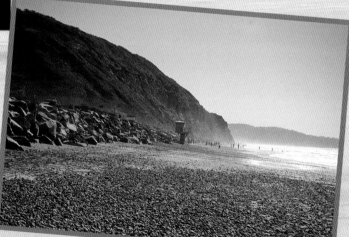

The Torrey Pines sandstone cliffs are three hundred feet high. You can just imagine Charles Lindbergh's flight here in 1930 when he soared from the top of Mount Soledad to the beach just west of Del Mar.

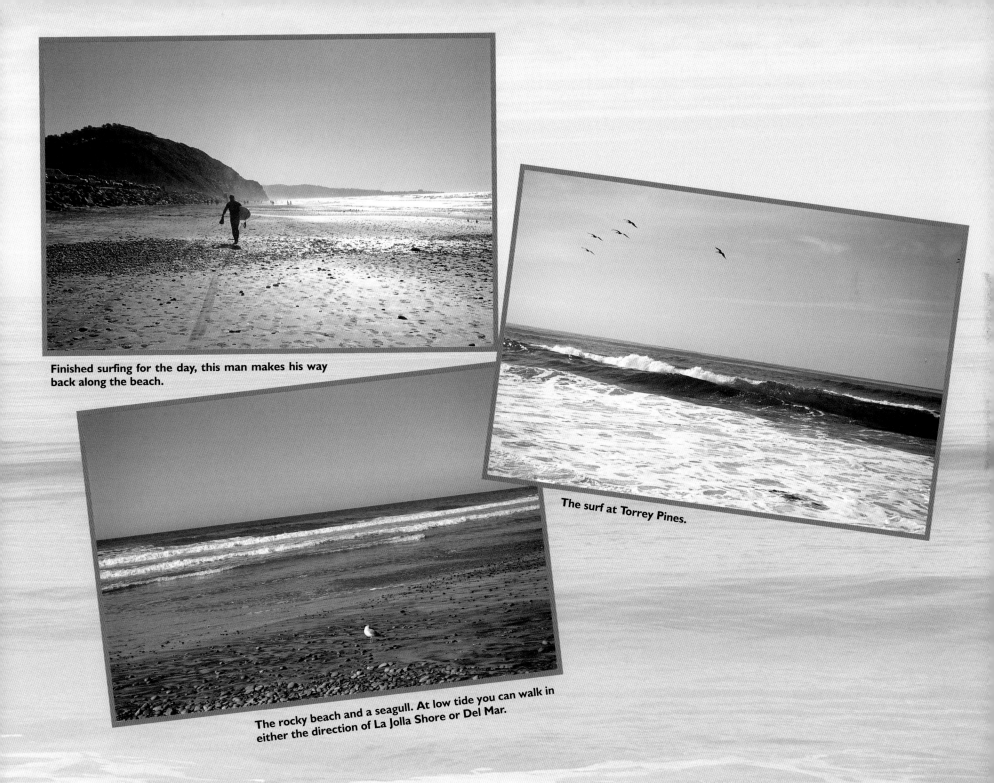

Finished surfing for the day, this man makes his way
back along the beach.

The surf at Torrey Pines.

The rocky beach and a seagull. At low tide you can walk in
either the direction of La Jolla Shore or Del Mar.

Christmas in La Jolla. The La Jolla Christmas Parade has a tradition of forty-nine years behind it with marching bands, decorated floats, antique cars and Santa. Not just a parade but also a street fair on Silverado Street with arts, crafts and food for sale, this year, 2007, will mark the parade's fiftieth year.

The shopping arcade with it's distinct Spanish mission architectural style, beautiful white washed walls and old bell on top was designed by Herbert Palmer. As you pass restaurants Fay Avenue and Prospect Street you will see the Arcade building. Through the Arcade are a number of specialty shops. The building runs from Girard to Prospect.

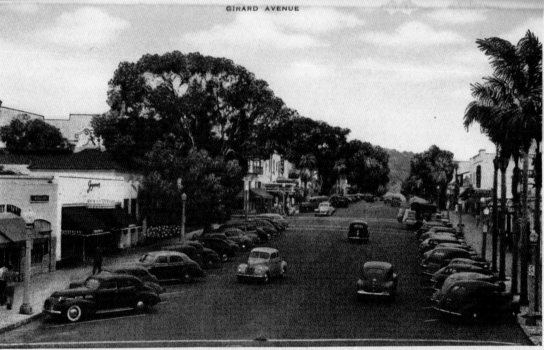

Then. Girard Avenue in the 1950s. Girard Avenue is the main street of La Jolla Village and contains many stores, art galleries, businesses, and, of course, places to eat. Vintage postcard c.1950s.

The Grande Colonial, located on Prospect Street, is a historical landmark. It's the oldest original hotel in La Jolla. When the hotel opened in 1913 it charged $1 a day. It is said to be haunted by former occupants of the rooming house whose wild parties continue to this day.

The Florence Riford Library on Draper Avenue. In March 1988 the public library, Athenaeum and Parker building were granted a protective historic site designation. The library building on Wall Street is where the original La Jolla reading room was established in 1899. The building, constructed in 1921, was designed by William Templeton Johnson.

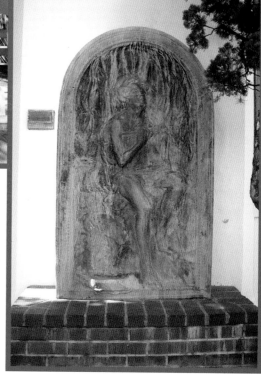

A carving outside of the library.

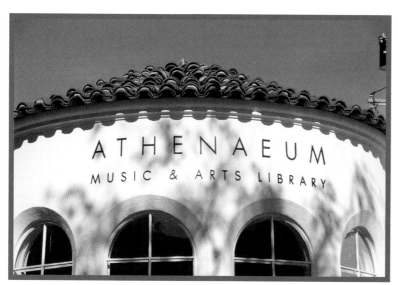

The Music and Arts Library. Designed by architect William Lumpkin in 1957, the library holds rare music and arts books and manuscripts.

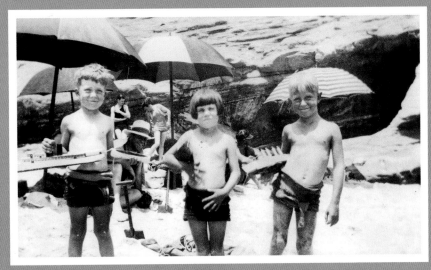

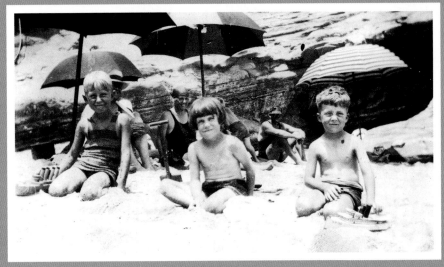

Children playing at La Jolla Cove. Vintage set of three photos, c.1930s.

The cove is one of the most photographed beaches in San Diego.

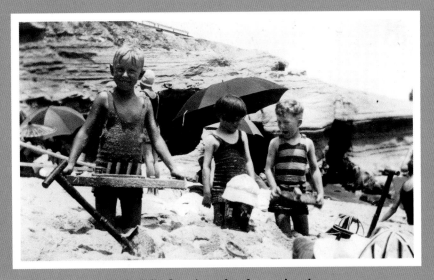

The coarse sand at La Jolla Cove is perfect for sandcastles.

An ocean view from La Jolla Cove.

A view of the ocean.

Collecting shells and creating one-of-a-kind shell-masterpieces is a day well spent in The Cove.

Finding treasures in the sand.

41

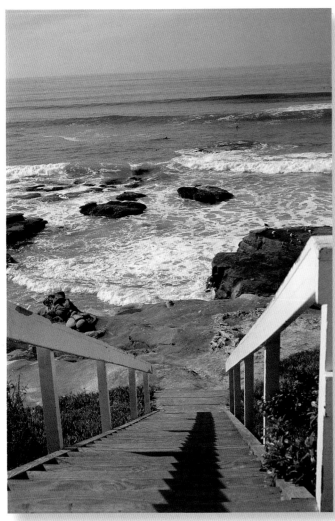

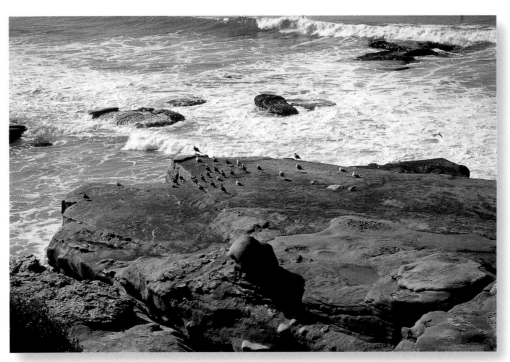

The rocky shore of Windansea Beach is known not only for its beauty but the surf break created by underwater reefs.

Steps down to Windansea. Chuck Hasley formed the Windansea Surf Club in 1962 so that avid surfers in the area could compete in a Los Angeles/Malibu surf competition.

Close-up of the rocks.

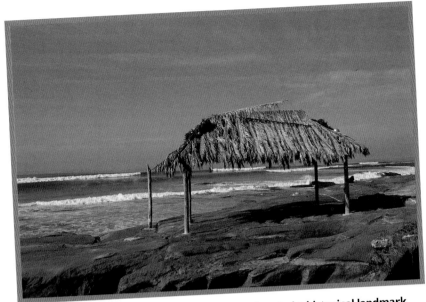

The Surf Shack at Windansea Beach was designated a historical landmark by the San Diego Historical Board in 1998.

The shack, waves and the Sanyo blimp in the distance.

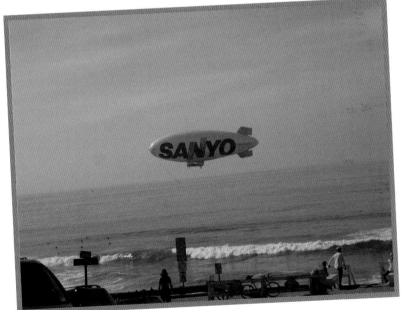

The Sanyo Blimp. *Courtesy of KEY.*

Abandoned bike—for surfing? The public parking lot at Windansea only holds eighteen cars so if you are not wanting to search for street parking a bicycle is a better option.

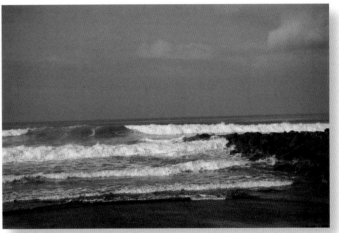

Windansea ranks along with Malibu, San Onofre and Huntington beaches as one of the top surf places.

Big waves.

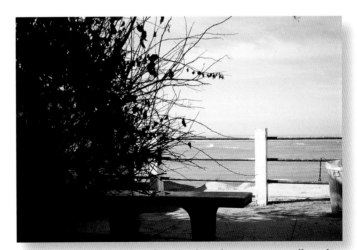

A private bench perfect for viewing the ocean, reading the morning paper or listening to the surf below. The pace of life seems to magically slow down once you have alighted yourself to a bench such as this.

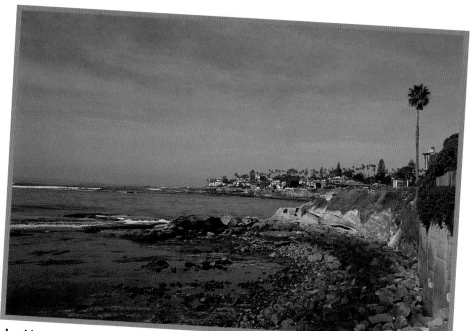

Looking towards La Jolla Village.

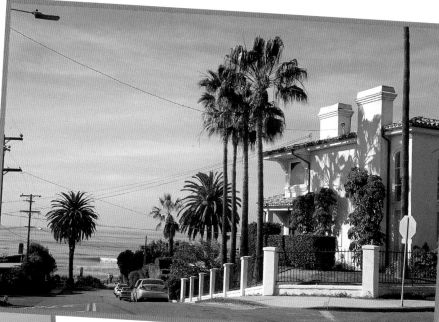

A million dollar view.

Spectacular homes near Neptune Avenue.

Album Three:

Pacific Beach

A beautiful strip of sand with crashing waves lures the locals, tourists and surfers. This lively crowd all vies for towel space during the peak summer months. In the winter the place is almost deserted but watch out on weekends, especially the Fourth of July, for massive crowds. If you have the urge to walk along a busy boardwalk or swim in endless waves, then this is the place.

That's V. Interesting?

What took thirty minutes in 1888? A one-way trip on the San Diego and Old Town Railway.[6] For the rate of twenty-five cents you could be hurtling, okay, going faster than a donkey ride, towards San Diego's downtown. The same trip today with traffic just might take you about the same amount of time!

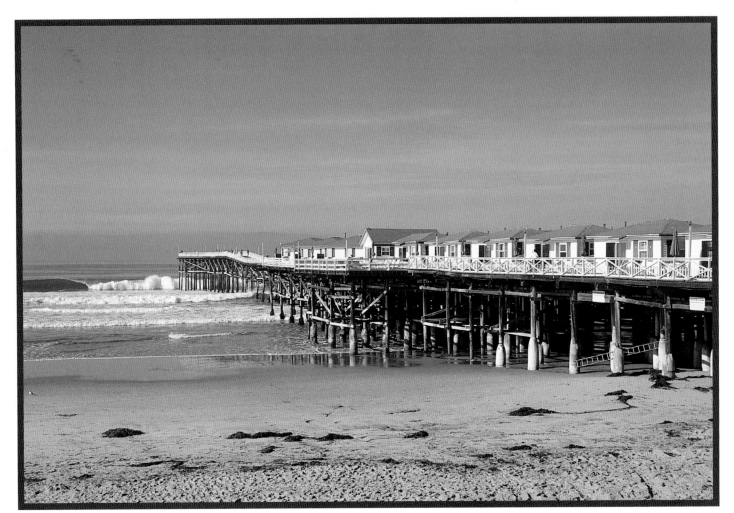

We're not in Kansas anymore

Earl Taylor, a developer from Kansas, conceived the idea for the Crystal Pier in 1927. Earnest Pickering first financed it. Why a pier here? These savvy realtors were hoping that a pier would make Pacific Beach a more attractive area to live in for prospective buyers. When Pickering left the project due to financial difficulty, Neal Nettleship gained ownership and renamed the pier "Crystal Pier."

Today you can access the pier from the boardwalk or walk up the steep steps from the beach… if your energetic eight-year-old deems it the better way. Twenty-six Cape Cod style white cottages with blue shutters dot the pier. Cutouts such as pelicans, seahorses, and beach-umbrellas adorn the shutters and echo the beach theme. The cottages are part of The Crystal Pier Motel property.

The Crystal Pier opened on July 4, 1927. It had a midway and even a dance-floor. Due to major structural flaws the pier closed and did not open until ten years later. The new pier featured hotel cottages instead of a midway.

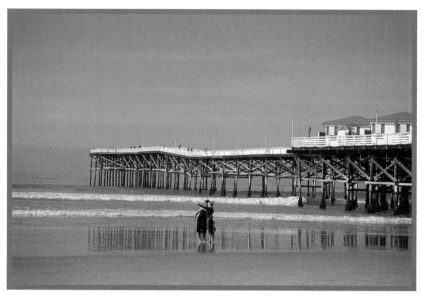

A couple taking a picture by the Crystal Pier.

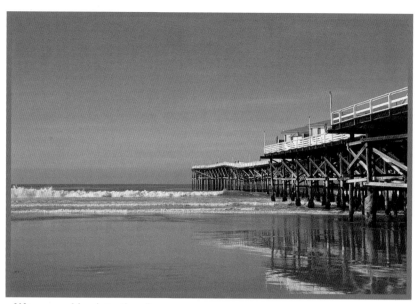

Waves crashing into the pier.

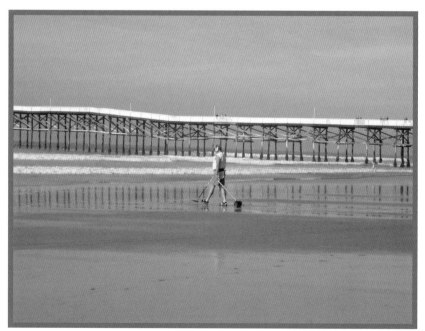

Searching for treasure.

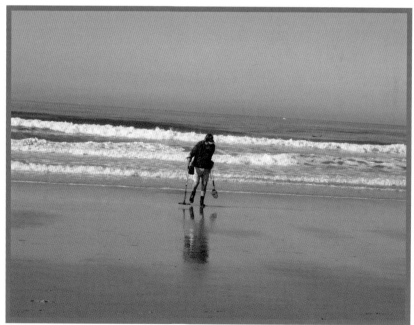

Gold, diamond rings or perhaps loose change.

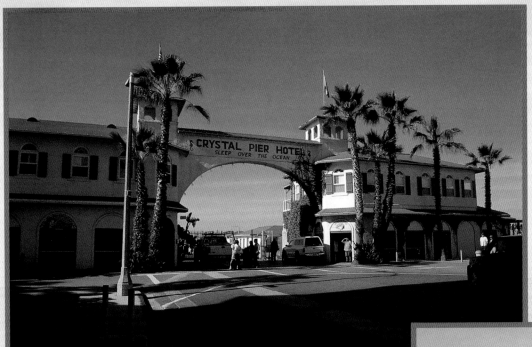

The Crystal Pier Hotel entrance.

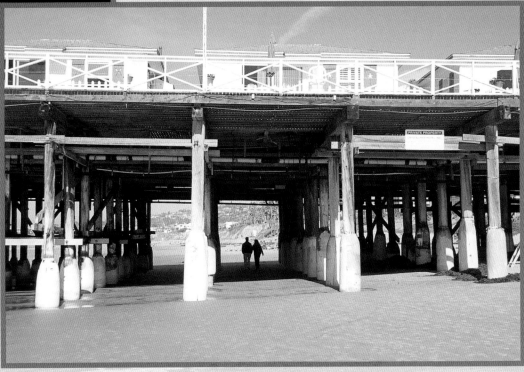

Under the pier.

The pier was dedicated in April 18, 1926 and opened in July 1927. The main attraction was the towered ballroom at the end of the pier whose crystal ball high above the dance floor gave the pier its name.

Perhaps there is no better way to experience the surf than to sleep above it. There are twenty-nine cottages in total with some on land, so you have to specify you want one over the water.

On the boardwalk

Put on some shades, rent a bike and cruise along the boardwalk. The vibrant three-mile stretch of boardwalk is home to an array of surf shops, restaurants, rental stores and of course unique Pacific Beach characters. If you get tired, lock up that bike and go hunting for *tiki* statues, yes *tikis*. The San Diego Convention and Visitor's Bureau runs an imaginative tour through Pacific Beach and Mission Bay Park where visitors can discover the over 20 hidden Polynesian Tiki statues. Aloha!

Pigeon with pier in the background.

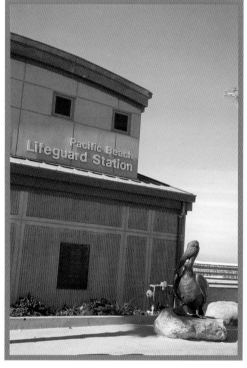

Pacific Beach Lifeguard Station.

Gemstones in Pacific Beach?

Around 1900 there were many streets in San Diego with duplicate names. The San Diego Common Council passed an ordinance that eliminated duplicate names,[7] and streets in a specific area have a theme. Pacific Beach names were chosen from precious stones and arranged alphabetically. Look for Garnet, Opal, Sapphire, Tourmaline, and other gemstones.

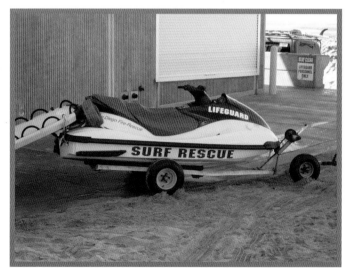

Rescue vehicle.

Octopus mosaic along the boardwalk. *Courtesy of KEY.*

An interesting wall mural. There are quite a few wall murals located in Pacific Beach in the Garnet and Cass areas. The murals are part of an area revitalization program.

Towering palms by Wahines surf shop on the boardwalk.

Yes it's just another colorful day along the boardwalk; one of the locals is taking his parrot for a walk. The weekly 'church on the beach' is also visible in the background.

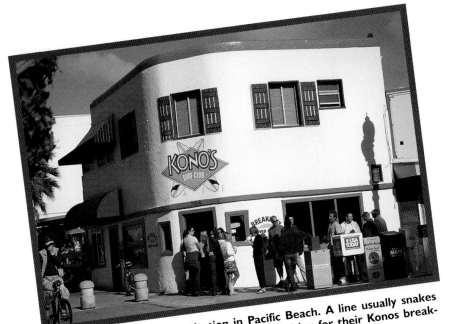

Konos Restaurant is an institution in Pacific Beach. A line usually snakes around the building with eager customers waiting for their Konos breakfast.

Breakfast amongst the palms. With a dog at their feet, paper in hand and a hot meal in front of you, residents of Pacific Beach know how to spend a leisurely weekend morning.

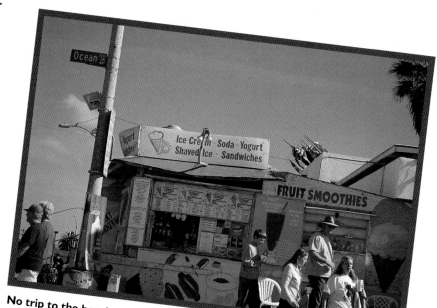

No trip to the beach would be complete without ice cream.

Joe's Crab Shack. A family-style restaurant serving, what else, seafood.

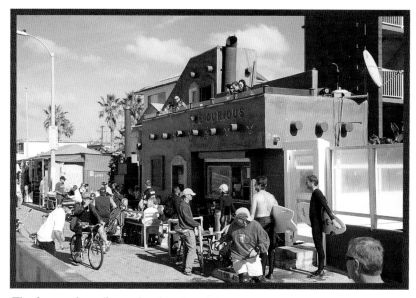

The forever busy 'be curious' restaurant.

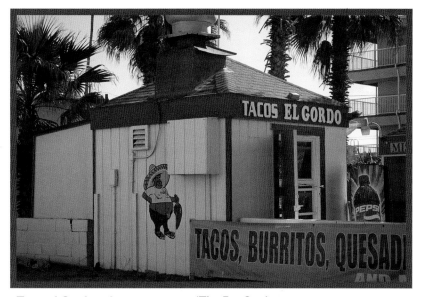

Tacos el Gordo—the name means 'The Fat One'.

After the ice cream, stop into one of the many tourist stores, where racks of postcards are in abundance.

A surf mural on one of the boardwalk food shacks. *Courtesy of KEY.*

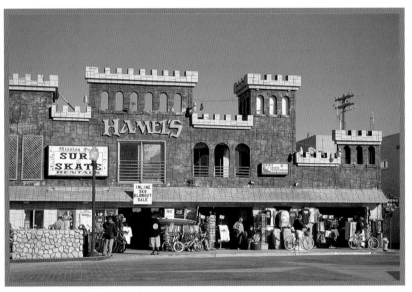

Hamels Surf and Skate. Brothers Dan and Ray Hamel opened the store in 1967.

A beach cruiser is perfect for taking in the sites of the boardwalk.

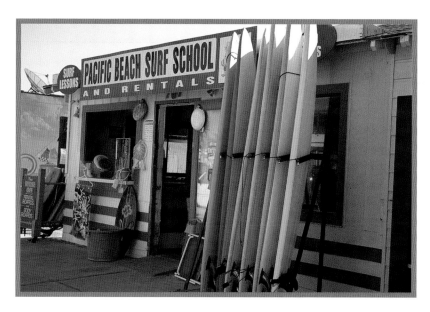

Pacific Beach Surf School. The Pacific Beach Surf shop is the oldest in San Diego. Though the school's location and ownership has changed since it's first inception, the store's devotion to surfing hasn't. The main store is located in the **Pacific Promenade on Mission Boulevard.**

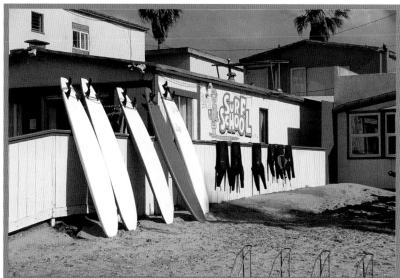

Surf boards and wet suits left out to dry.

Colorful surfboards just steps from the beach await their next student. Learning all about surf etiquette, water-safety, the pop-up, and some dive-techniques is a great way to spend an hour or more in **Pacific Beach.**

Mission Beach

Hear... the screams and rumbles coming from the midway. See... the waves rolling into the pier. You can almost smell the ocean breeze and breakfast cooking at the Konos Surf Club. This is Mission Beach. It's a slice of Coney Island on the West Coast and, unlike on the East Coast, this boardwalk doesn't shut down for the winter. It's little wonder then that Mission Beach is the busiest of all San Diego beaches.

The bustling boardwalk is home to brightly colored beachwear shops, restaurants, tourists, locals, cyclists and joggers. Check out the gift shops for postcards, beachwear and I LUV SD paraphernalia. Watch the kids on the Flow Rider, a wave machine that delivers never-ending waves for surfers to ride. Hang Ten!

Before you delve into the excitement of the amusement park, follow the wet footsteps left behind by surfers and wander down one of the side streets. Pastel craftsman cottages, inviting patios with driftwood chairs offer a glimpse of a laid back and purely California lifestyle. This is truly the Mission experience; an amazing array of activity on the boardwalk and calm and quiet only a side street away.

MISSION BEACH

Two sisters enjoying the day at Mission Beach.
Vintage postcard, c.1930s.

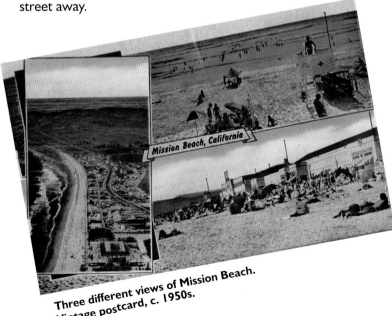

Three different views of Mission Beach.
Vintage postcard, c. 1950s.

The Boardwalk

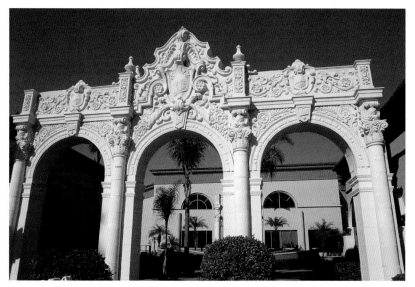

The Wave House Athletic Club on Ocean Front Walk. The flow rider sports' machine is set up here and produces an endless wave. Wave House is also home to 'The Plunge', a 175-foot-long pool built in 1925.

Choose your speed along the boardwalk. A leisurely stroll, an intense jog or be like 'SlowMo' man, a Mission Beach attraction with his distinct slow motion inline skate technique.

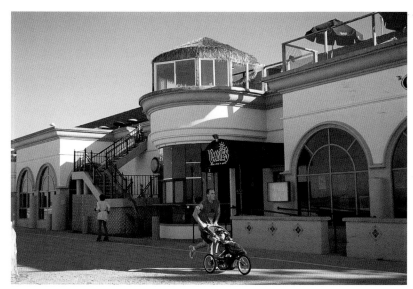

The boardwalk connecting Mission and Pacific beaches is three miles long. Preferring to run outdoors, a man pushes a baby-jogger past the Mission Beach health club.

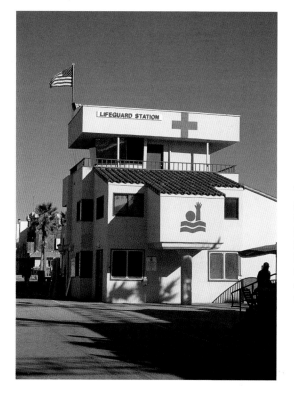

The Mission Beach lifeguard station is located at the foot of Ventura Street beside the Giant Dipper Roller Coaster. It is staffed year round with more lifeguards on duty during the peak summer months.

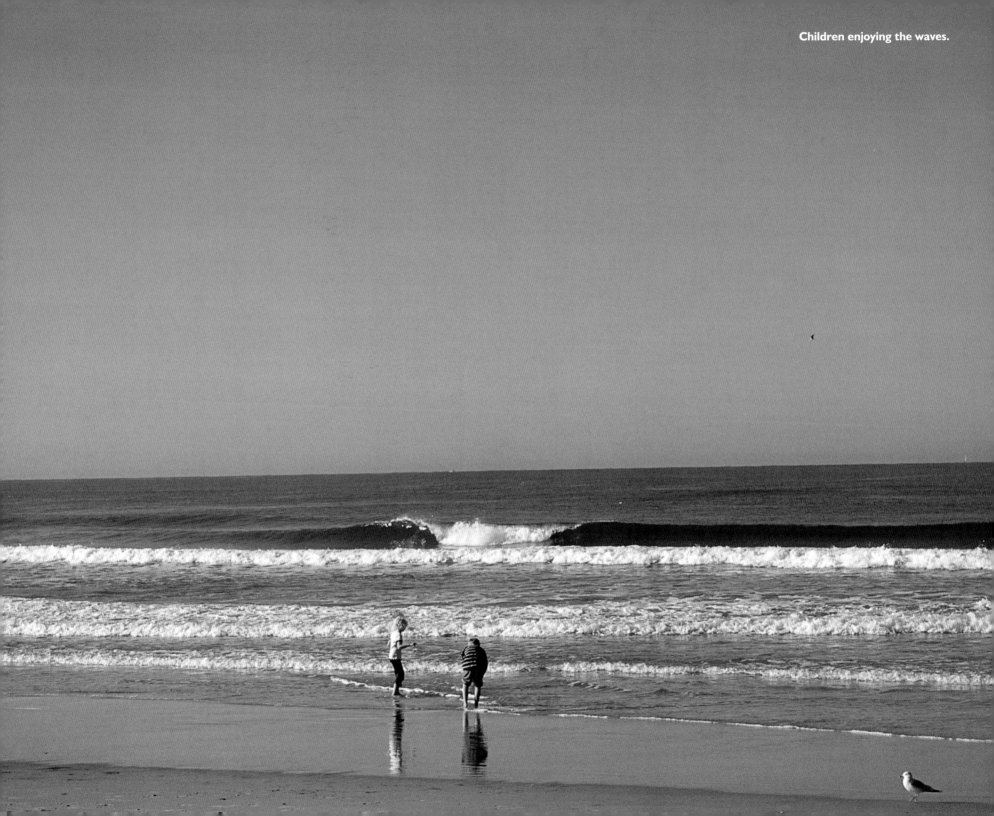

Sand

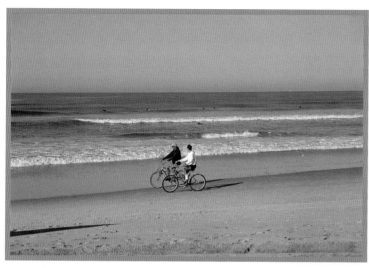

A couple enjoys a bike ride along the sandy shore. During the winter months it's easy to forget that Mission Beach is the most popular beach in San Diego. Tens of thousands of people visit Mission and Pacific beaches over the Fourth of July weekend.

Seagulls on the shore.

A seaweed encrusted rock.

The surf lineup.

A Christmas tree on the beach. *Courtesy of KEY.*

Sardines

If you thought that the homes in Mission Beach were tightly packed together like sardines in a can, you weren't wrong. Mission Beach is the most densely populated residential area in San Diego. Not surprisingly it also contains the smallest lot sizes.[8] Does that mean that you could potentially change your neighbor's television channels?

A secret stairway.

A white surf gate. *Courtesy of KEY.*

A surfer crossing gate sign.

Rinse off the sand before entering. By the looks of the pile at the door, someone has obeyed the sign.

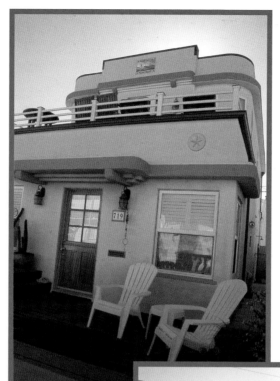

An art deco cottage.

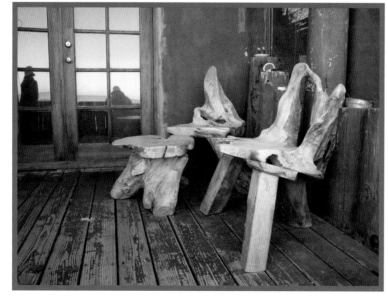

What could be more beachy than a driftwood furniture embellished porch. *Courtesy of KEY.*

A 1920s craftsman style cottage. Mission Beach is just five minutes to Seaworld and ten minutes downtown, making it a favorite for tourists looking for short and long-term accommodations.

The Campbell beach house is a historic adobe style cottage, c. 1933. Located on Oceanfront Walk, it's now a rental accommodation.

A Mediterranean villa style home.

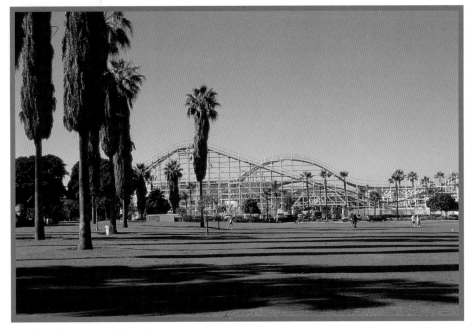

A view from the children's park.

Belmont Park

Look! It's the Tilt-a-Whirl, Crazy submarine, Liberty Carousel and, of course, the Giant Dipper. Belmont Park, conveniently located just off from the boardwalk, has the distinction of being San Diego's oldest amusement park. The Big Dipper coaster at Belmont Park was built in 1925. Today it is one of only two remaining seaside coasters. The top of the coaster provides the best views of the beach.

The coaster has literally had its ups and downs. From the 1920s and through to the 1940s, the coaster drew crowds, but by the time the 1970s rolled around the park had fallen into disrepair and closed in 1976. In the 1980s the Dipper was threatened with demolition, but a citizens group banded together to save it. Luckily, they succeeded in having the coaster designated as a National Monument. Now fully restored, the coaster reopened to the public in 1990.

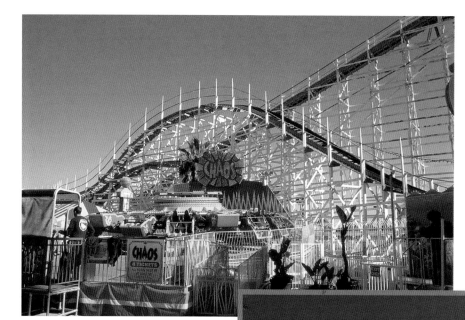

The Giant Dipper received its National Historic Landmark designation in 1978.

Just how fast?

Whizz. Fly. Rumble. When the Giant Dipper reaches its peak speed of forty-five miles per hour, you might feel as if you're going to fly off the track. Your heart will definitely be in your mouth as the coaster plummets seventy-three feet from its highest drop. After exiting the ride, don't be surprised if you jump right back into line!

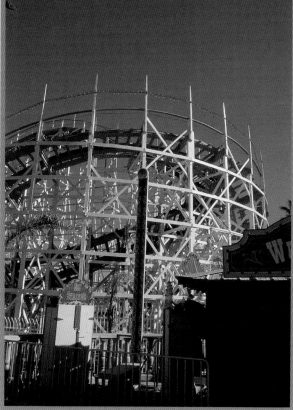

Steep hills, sharp curves and high speeds make this ride one not to be missed.

The Giant Dipper.

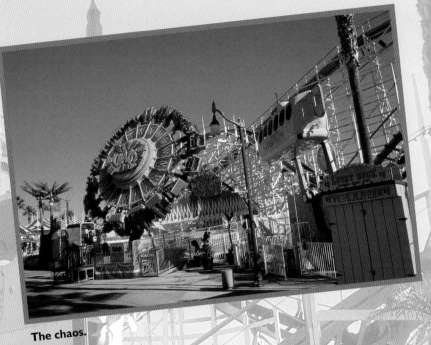

The chaos.

The Giant Dipper with an ice-cream taste tester in front.

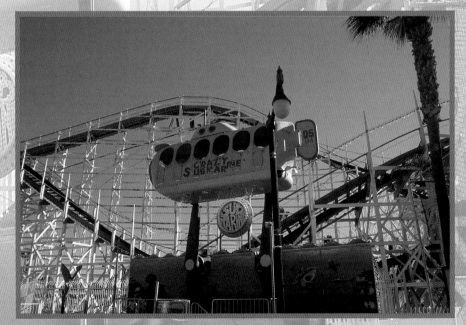

The Crazy Submarine. A ride for children that carries them up into the air.

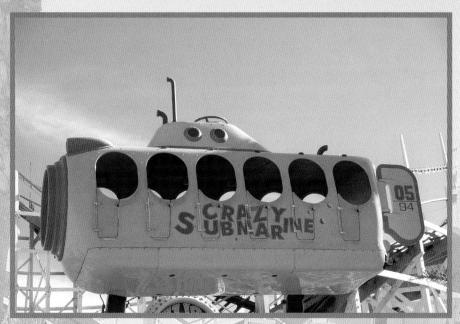

The Crazy Submarine up close.

The Liberty Carousel is an antique reproduction carousel. The hand-painted scenes are of Father Junipero Serra as he is about to discover Mission San Diego, the Spirit of St Louis flying over the Big Dipper, the Hotel del Coronado and a 1920s beach scene. The carousel paintings were based on photographs provided by the San Diego Historical Society.

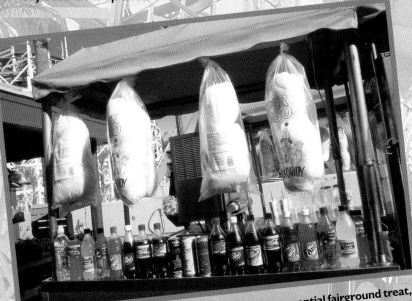

Sweet and sticky goodness. Cotton candy, the quintessential fairground treat, is strung up for the next visitor. The first cotton candy was sold in 1904 at the St. Louis World's Fair—who knew then that spun sugar and food coloring would become such a hit?

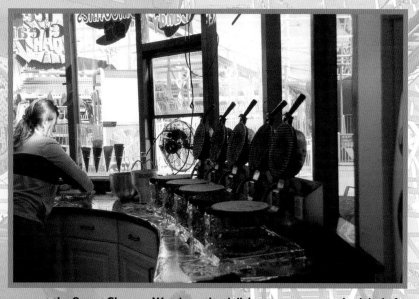

Waffle cones at the Sweet Shoppe. Watch, as the delicious cones are made right in front of you. Choosing which type to have, sprinkles, multi-colored or just plain isn't that tough—just plan on coming back for seconds. According to our official ice cream tester, who has trained on three continents, they are certifiably yummy ... and, big surprise, leaves no room for dinner!

Mission Bay

The Welcome To Mission Bay Sign. Mission Bay Park is the largest man-made aquatic park in the United States. Beyond the sign are 4,235 acres of park almost evenly split between land and water use. This park is only minutes from downtown San Diego and Seaworld. With twenty-seven miles of shoreline you are spoilt for activities such as boating, cycling, jogging or even swimming.

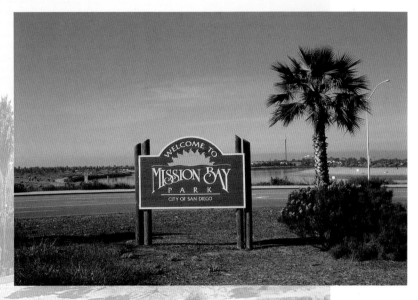

Where can you water-ski, rollerblade, mountain bike, inline skate and sail a yacht? Why in Mission Bay of course. In the 1940s Mission Bay was dredged and a new aquatic recreation area was built. Today you will likely see cars with bikes on top—eager mountain bikers ready to take full advantage of the trails. Young families come here to picnic and, if you like more exciting fare, well there is a waterskiing jetty. Mission Bay Park boasts an amazing fifteen million annual attendance![9] So, there must be something to this man-made aquatic park.

The view from Mission Bay Park.

What's in a name?

In 1542 Juan Cabrillo's expedition named present day Mission Bay, False Bay. Why? Its marshlands and mudflats sometimes confused sailors. These early mariners thought they were in the larger San Diego Bay. Oops, wrong turn. In 1888, poet Rose Hartwick Thorpe wrote a poem in which she renamed the bay "Mission Bay."

Mission Bay, Mission Beach and Pacific Beach Resources

- *Pacific Beach*
www.pacificbeach.org
- *Belmont Amusement Park*
www.belmontpark.com
- *The Giant Dipper*
www.giantdipper.com

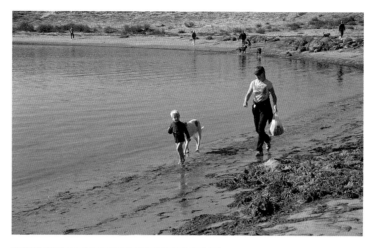

Strolling along the muddy shores of Fiesta Island, a lucky dog goes for a morning romp. Dogs are permitted off leash at all times in this area.

Running along the shore is an option to the paths that wind around the aquatic park. Every month there always seems to be a 5k, 10k or even a marathon happening somewhere in San Diego County. Some of the better known ones include the Pacific Beach Turkey Trot, the Jingle Bell Run in Balboa Park and the Rock and Roll Marathon.

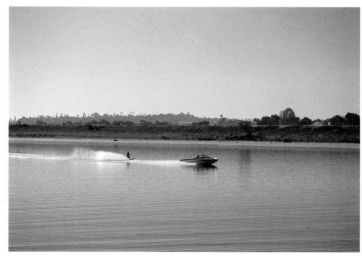

Water skiing at Crown Point Beach. All you need are skis, rope, a life jacket and oh, yes, someone to drive a boat and you'll be up and then down (based on personal experience) in no time flat.

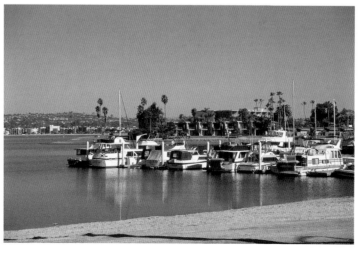

Mission Bay Marina.

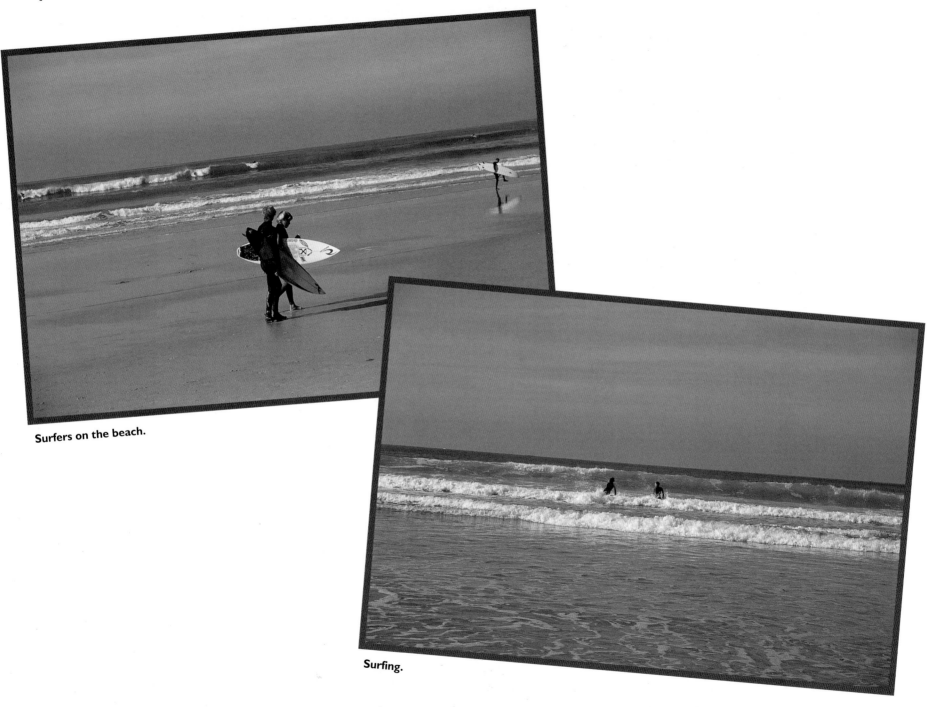

Surfers on the beach.

Surfing.

Album Four:

POINT LOMA
NAZARENE
· FOUNDED 1902 ·
UNIVERSITY

CHURCH OFFICE

Point Loma Nazarene University is just south of Sunset Cliffs. Originally this area of Point Loma was where the Theosophical Society of 1896 began.

Ocean Beach and Sunset Cliffs

Four hundred feet above the Pacific Ocean, the cliffs of Point Loma provide a spectacular view of the San Diego coastline. Many seagulls and other shorebirds make their home in these cliffs, ample opportunities for naturalists. Walking cautiously down the cliffs to the shoreline will reveal tide pools with anemones, periwinkles, wooly sculpins and other sea creatures. Ranger-led tours of the tide pools leave the Cabrillio National Monument Park daily and are a wise choice for the visitor who is not familiar with the area.

The heavily eroded cliffs establish the border where the western shore of Point Loma meets the Pacific Ocean. This area is Sunset Cliffs. It is no longer possible to walk along the oceanside of Sunset Cliffs Boulevard as erosion has eaten away the road. Sections of the road have even had to be moved in!

Sunset Cliffs Park was originally landscaped in 1915 by sporting goods magnate Albert Goodwill Spalding. Rustic railings, stairways, a thatched shelter and a Japanese style arched bridge were all incorporated into the design. The area was given to the City of San Diego but unfortunately it has deteriorated. Vintage photo postcard of Sunset Cliffs, c.1910s.

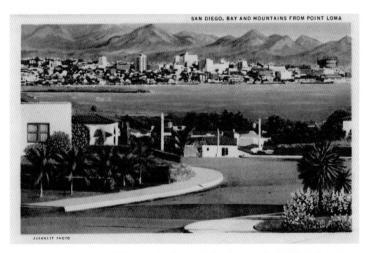

San Diego Bay and Mountains from Point Loma. In 1602 Sebastian Vizcaino and his ship San Diego reached the harbor now known as Mission Bay and Point Loma. The name San Miguel was then changed to San Diego. The area is named for both his ship San Diego and the Catholic Saint San Diego de Alcala. Vintage postcard, c.1950s.

The Ocean Beach pier.

Ocean Beach was built in the 1900s. It did not have a pier to lure prospective buyers, instead it had Wonderland—an amusement park that boasted having the largest roller coaster on the West Coast. Hey, who needs a pier when you have fun rides? Wonderland opened in 1913 but its reign as a premier attraction on the coast would sadly end a short five years later. In 1916, a bad storm washed it away.

What's in a Name?

Billy Carlson and Frank Higgins, real estate developers in the late 1880s, named Ocean Beach. Today it is known as "OB." Unfortunately for them their development did not do very well as it took two and a half hours to travel to downtown San Diego by carriage.

The lifeguard station.

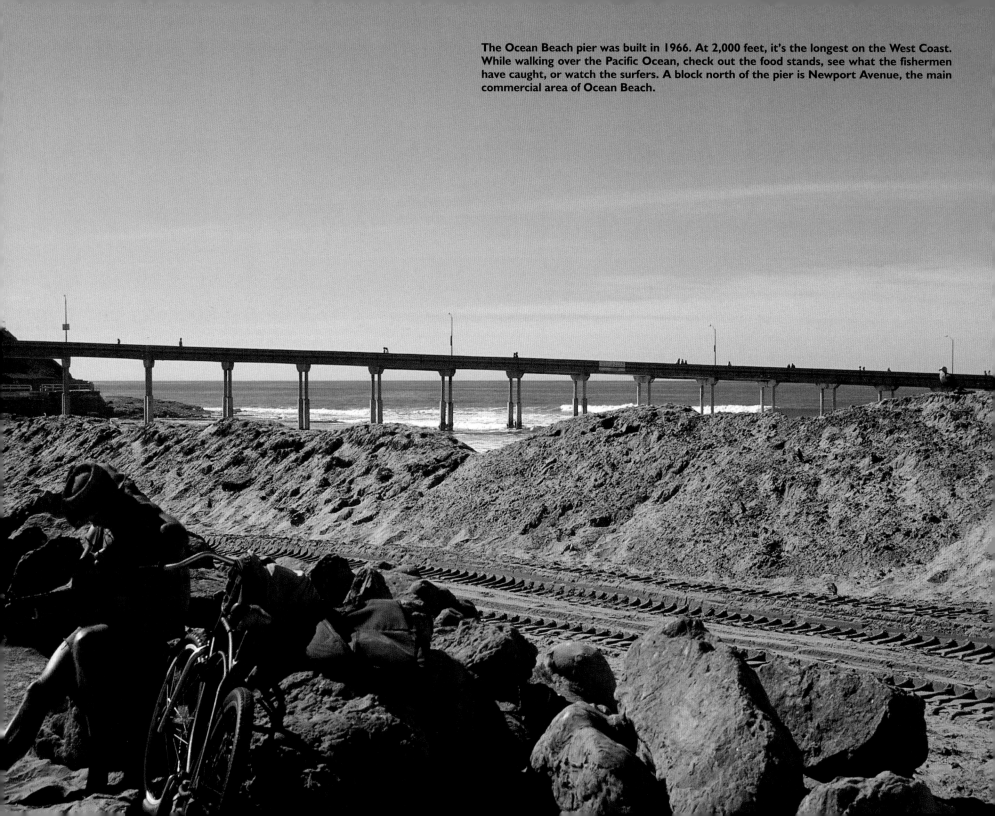

The Ocean Beach pier was built in 1966. At 2,000 feet, it's the longest on the West Coast. While walking over the Pacific Ocean, check out the food stands, see what the fishermen have caught, or watch the surfers. A block north of the pier is Newport Avenue, the main commercial area of Ocean Beach.

Today Ocean Beach is a laid-back beach community just perfect for indulging in the three S's—swimming, surfing and sunning. With the locals out-numbering the tourists three to one, perhaps this is why Ocean Beach offers such an authentic Southern California experience. The December Holiday Parade, weekly Farmers Market, Jazz Festival and the Ocean Beach Street Fair and Chili Cook Off are but a few events that demonstrates the great sense of community. Jazz at the beach, good food and a place to surf—wow! This tight knit group of San Diegans is obviously onto a good thing.

Ocean Gifts and Shells on Newport Avenue.

The best way to cool off on a hot day is to nip into Lighthouse Ice cream and Soda on Newport Avenue. Even your best friend can have a drink of water outside while you are waiting on your order. The waffle ice-cream sandwich is highly recommended.

After spending a morning at the beach, wander down Newport Avenue, past the International hostel to Hodads. This burger haven is known for its monster surf burger and a great veggie burger as well. You can people watch through the open-air window or soak up the surfer décor.

This beach is going to the dogs

Fido is welcome at the northern end of Ocean Beach, which is known as Dog Beach. In 1972 it was one of the first official leash-free beaches in the States. Your pooch could run without a leash all day long and, hey, who knows he might become as famous as 'Rocky the Surfing Dog'? Dog Beach is such a great beach that it was even named one of the 'Top Ten Beaches in Southern California' by the Travel Channel in 2001. Okay, now it's time to find your dog an agent!

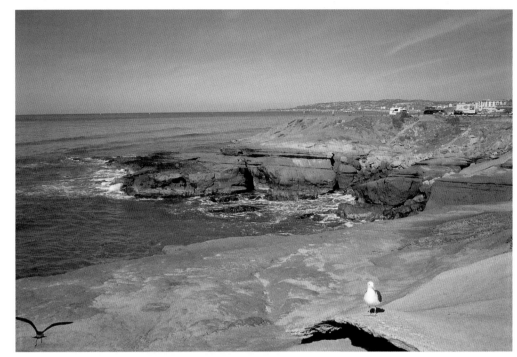

Sunset Cliffs.

Ocean Beach and Sunset Cliffs Resources

- *Dog Beach*
www.dogbeachsandiego.org
- *Ocean Beach*
www.oceanbeach.com
- *Ocean Beach Mainstreet Association*
www.oceanbeachsandiego.com
- *Eye on OB*
www.eyeonob.com

The Sunset Cliffs.

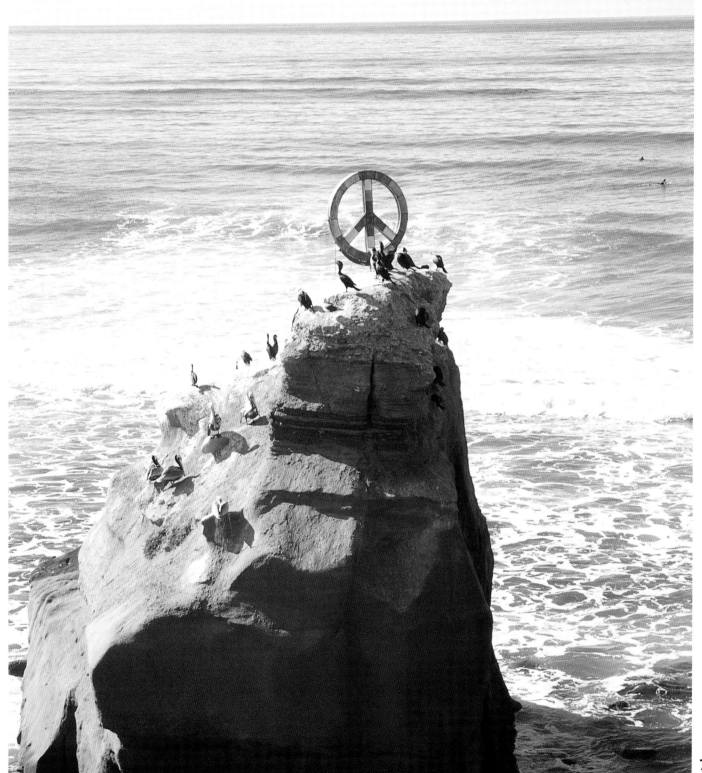

The Sunset Cliffs peace sign. At this same site a mysterious artist has left behind other sculptures including a crab, a tiki, and a pterodactyl. Drive past the peace sign to find parking after the boulevard forks. Hike down the cliff and over sea rocks until you reach the coarse sand and spend some time looking in the tide pools.

Album Five:

More Beachfront Cities

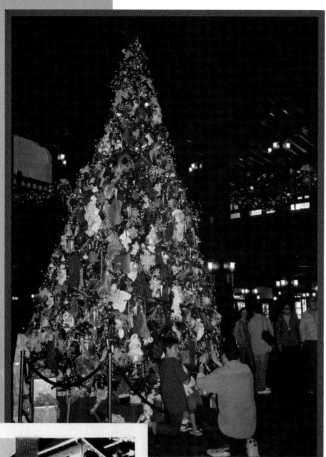

In 1904 The Del unveiled the first electrically lit Christmas tree in the world.

Coronado

Across the Silver Strand Boulevard, over the San Diego Coronado Bridge or by boat to Ferry Landing marketplace, the Crown City is home to eighteen miles of white sandy beaches. The beaches were voted the second best in the nation by the Travel Channel. Walk on the sparkling sand or rent a cabana from the Coronado Hotel and watch the children industriously build sandcastles until the 'dragons' come and destroy them.

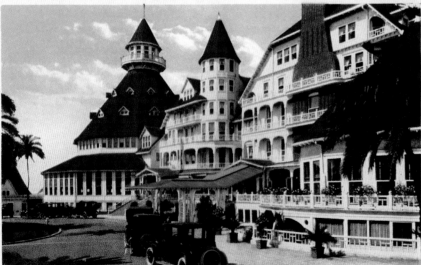

4305. MAIN ENTRANCE, HOTEL DEL CORONADO, CORONADO, CALIF.

The architectural firm of James, Merritt and Watson Reid designed the Hotel Del Coronado. It is reflective of a late Victorian architectural style. Vintage postcard, c.1920s.

What's in a Name?

On November 8, 1602 the Spanish navigator Vizcaino spied islands off the coast of San Diego. He named them "Las Yslas Coronadas" or the crowned ones. Coronado is also known as the Crowned City.

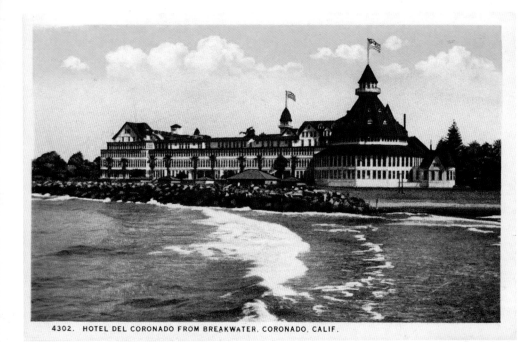

4302. HOTEL DEL CORONADO FROM BREAKWATER. CORONADO, CALIF.

Hotel Del Coronado from breakwater. Vintage postcard, c.1920s.

Hotel del Coronado

The main attraction besides the beach is the magnificent Hotel Coronado. In 1888 the Hotel del Coronado opened and over the years royalty, Presidents and movie stars have stayed there. Marilyn Monroe Tony Curtis, and Jack Lemmon starred in the 1959 film 'Some Like It Hot', which was shot at the Del. In the 1900s, if you couldn't afford a room at the Del, you were in luck as the owner of the hotel, John D. Spreckels, had opened a tent city south of the hotel.

Tent City was an affordable option to the pricier hotel. The striped tenting, wood planks on the floor and a solitary light bulb dangling from the tents ceiling attracted not only tourists but also local San Diegans! Tent City was so popular that it didn't close until 1939, closed to make way for the Silver Strand Highway. A slogan on postcards from the 1900s says it all—"If you have not lived in a palm-roof tent, you have not had the BEST- Coronado Tent City.' Wow—that's what you call a good sales pitch!

Whose been sleeping in my bed?

The answer to that might just be every President since Lyndon Johnson. But the Coronado didn't just play host to American elite. England's Prince of Wales visited the Hotel in 1920, a visit during which he met Wallace Simpson. Did you know he gave up his throne for her?

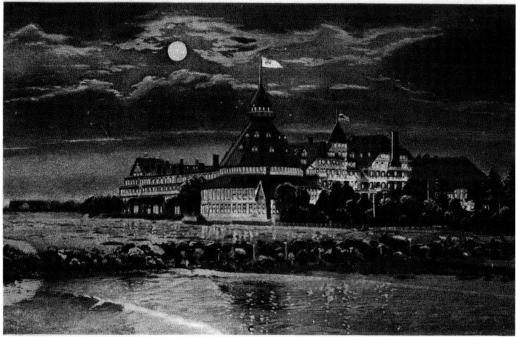

4316. HOTEL DEL CORONADO BY NIGHT, CORONADO, CALIF.

Hotel Del Coronado at night. The Coronado was the largest building outside of New York to be fully served by electricity at that time. Thomas Edison supervised the electrical installation. Vintage postcard, c.1920s.

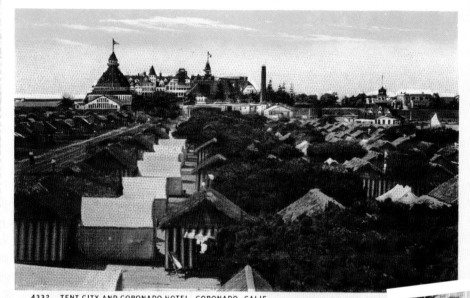

4332. TENT CITY AND CORONADO HOTEL, CORONADO, CALIF.

Tent City and Coronado Hotel.
Vintage postcard, c.1920s.

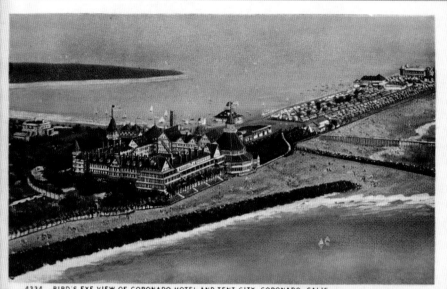

4334 BIRD'S EYE VIEW OF CORONADO HOTEL AND TENT CITY, CORONADO, CALIF

Bird's Eye View of Coronado Hotel and Tent City. Vintage postcard, c.1920s.

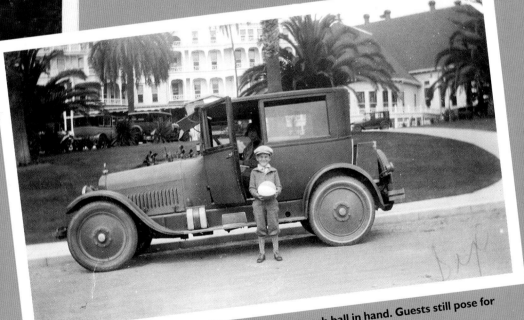

A young boy stands on the runner of an old car, his beach ball in hand. Guests still pose for
shots in front of 'The Del.' Vintage photograph, c.1930s.

Downtown Coronado

A fountain in downtown Coronado.

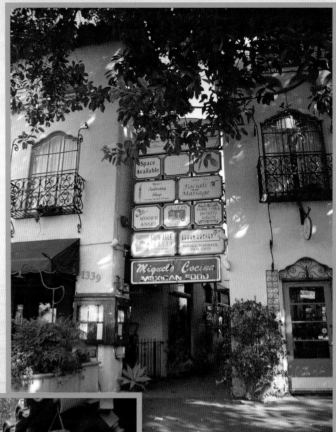

A shopping arcade.

The inner courtyard of the arcade.

The Papery's seahorse sign.

A Christmas window display.

What to do on the beach? This store provides the Coronado visitor with plenty of options: Sand shovels for digging and bamboo mats for lying on. *Courtesy of KEY.*

Display in basket of starfish and a beach sign. *Courtesy of KEY.*

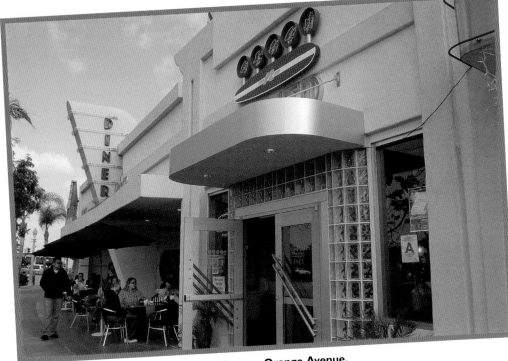

A burger and shake at the **Beach-N-Diner** on Orange Avenue.

The **Moo Time Creamery**. The popular store opened in 1998 and has served Hollywood stars, **NBA** players, and countless locals and tourists.

More great food.

The Pizzeria on Orange Avenue.

Chez Loma is a 4-star restaurant serving French cuisine.

Coronado cottages.

A cottage nestled in the trees.

The **Cossitt House** built in 1899 is a **Coronado Historical Landmark House.** Today it is a rental accommodation just blocks from the beach.

Practically every street is lined with beautiful historic homes.

A jovial frog lawn ornament.

A simple gate.

An impressive entrance.

A Coronado mansion.

Silver Strand and Imperial Beach

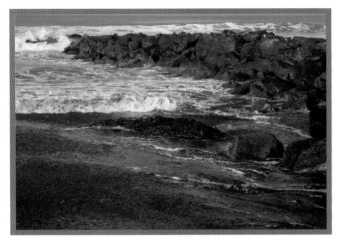

Ocean waves at Imperial Beach.

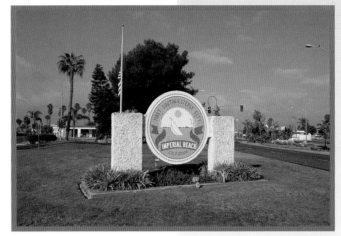

The Imperial Beach sign.

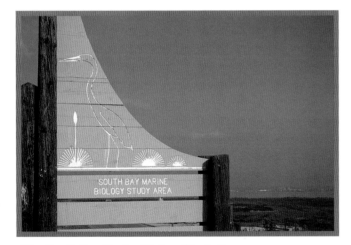

The South Bay Marine Biology Study Area.

A restaurant near the beach.

Biking by the wetlands.

Coronado Resources

- *The City of Coronado*
www.coronado.ca.us
- *The Coronado Visitor Center*
www.coronadovisitorcenter.com
- *Coronado Chamber of Commerce*
www.coronadochamber.com
- *Coronado Information Source*
www.welcometocoronado.com
- *Coronado Eagle and Journal-Local News*
www.coronadonewsca.com
- *Coronado Historical Association*
www.coronadohistory.org
- *Hotel del Coronado*
www.hoteldel.com

Parting view of the Coronado Bridge in the distance.

Museum of History and Art.

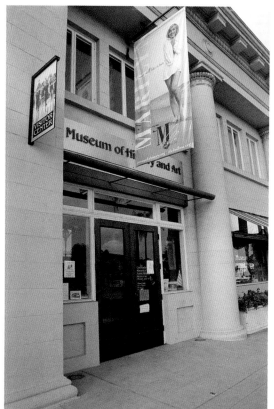

The Coronado Historical Association.

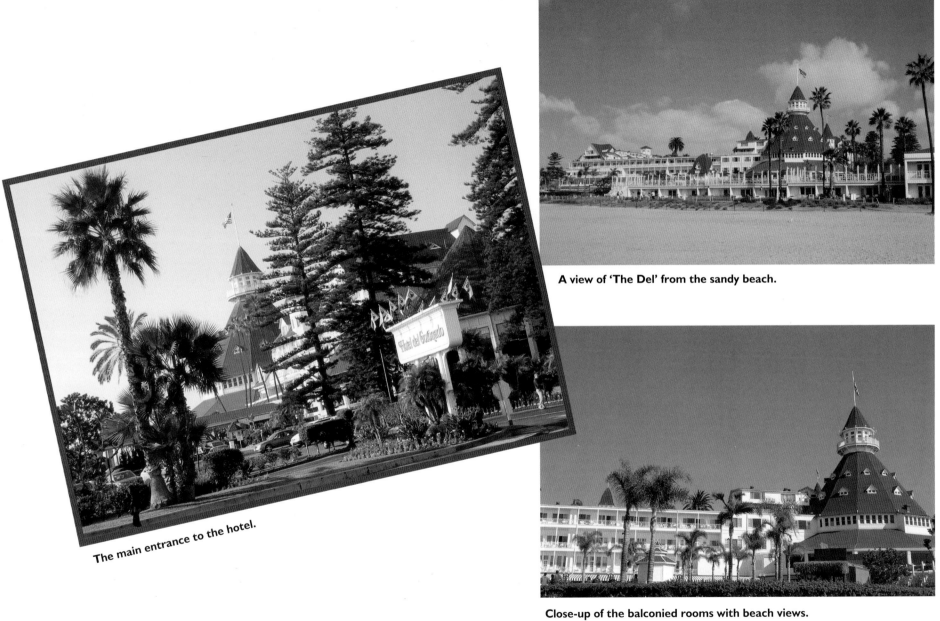

A view of 'The Del' from the sandy beach.

The main entrance to the hotel.

Close-up of the balconied rooms with beach views.

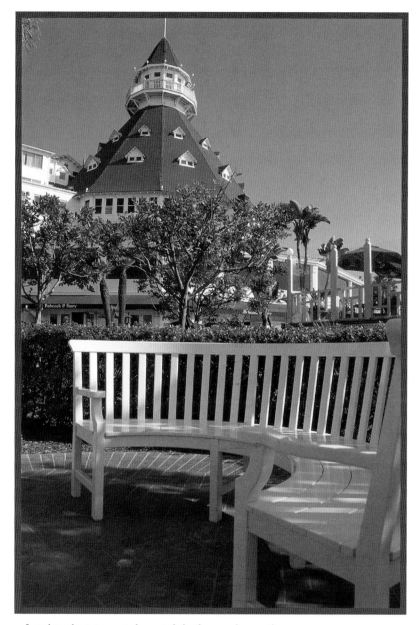

A quiet place to people watch is the garden patio.

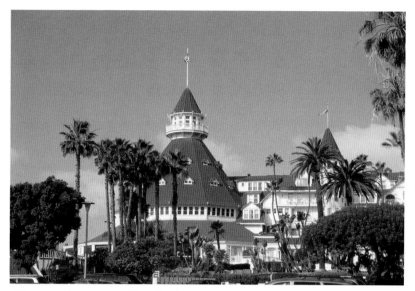

The number one wedding destination according to the **Travel Channel** is **The Del.**

The Coronado yacht club.

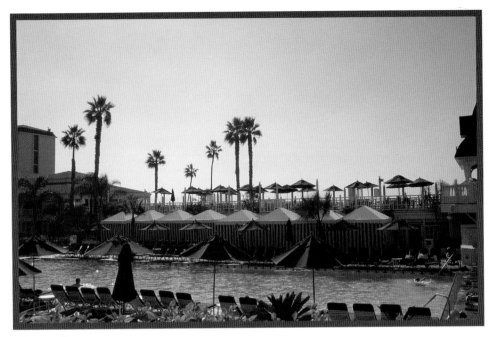

The pool area.

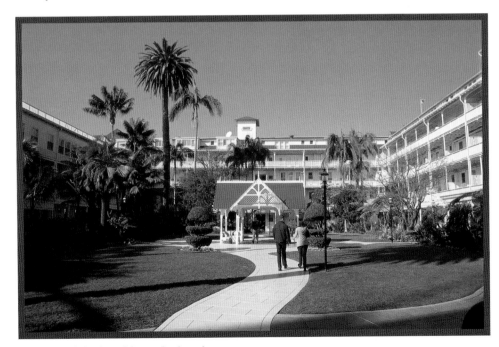

A view of the hotel from the beach.

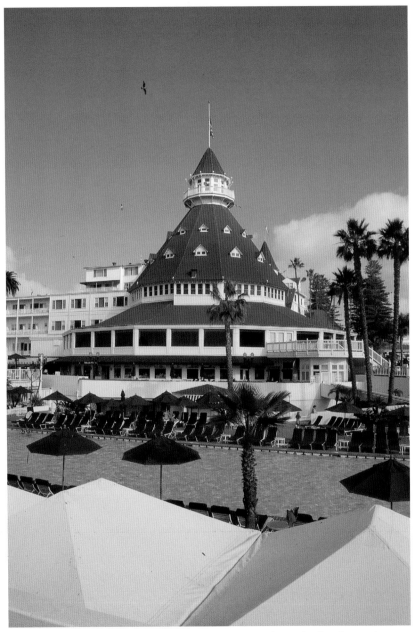

Canopies by the pool area.

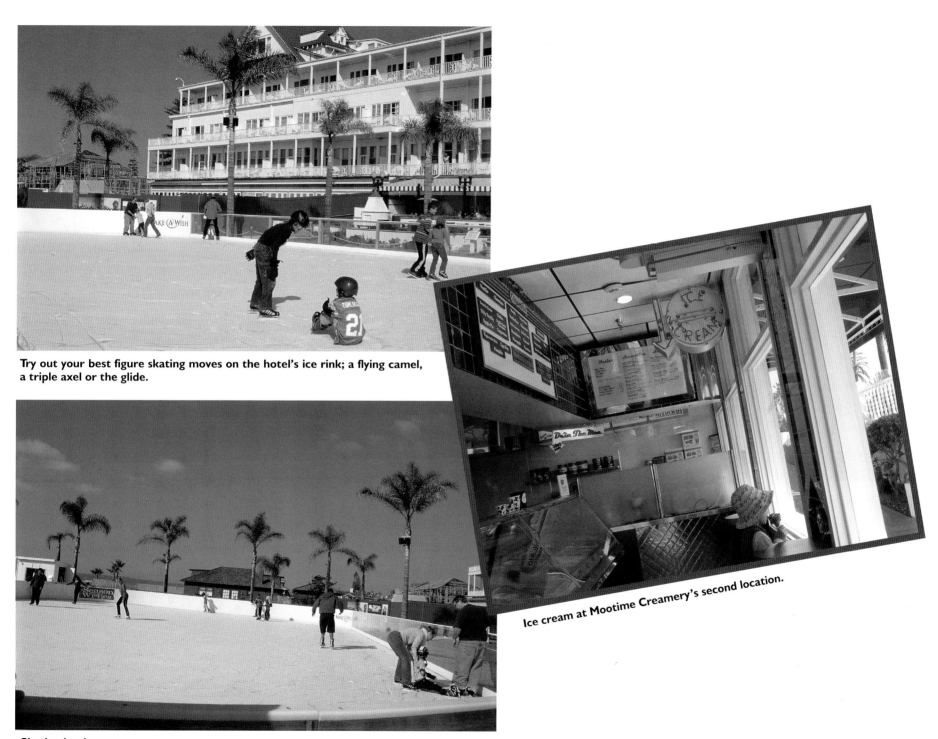

Try out your best figure skating moves on the hotel's ice rink; a flying camel, a triple axel or the glide.

Skating by the sea.

Ice cream at Mootime Creamery's second location.

In 1904 The Del unveiled the first electrically lit Christmas tree in the world.

A decoration on the Christmas tree. Christmas at The Del doesn't stop at the tree, but also includes theatrical productions, caroling and a yuletide dinner.

A peak inside the hotel.

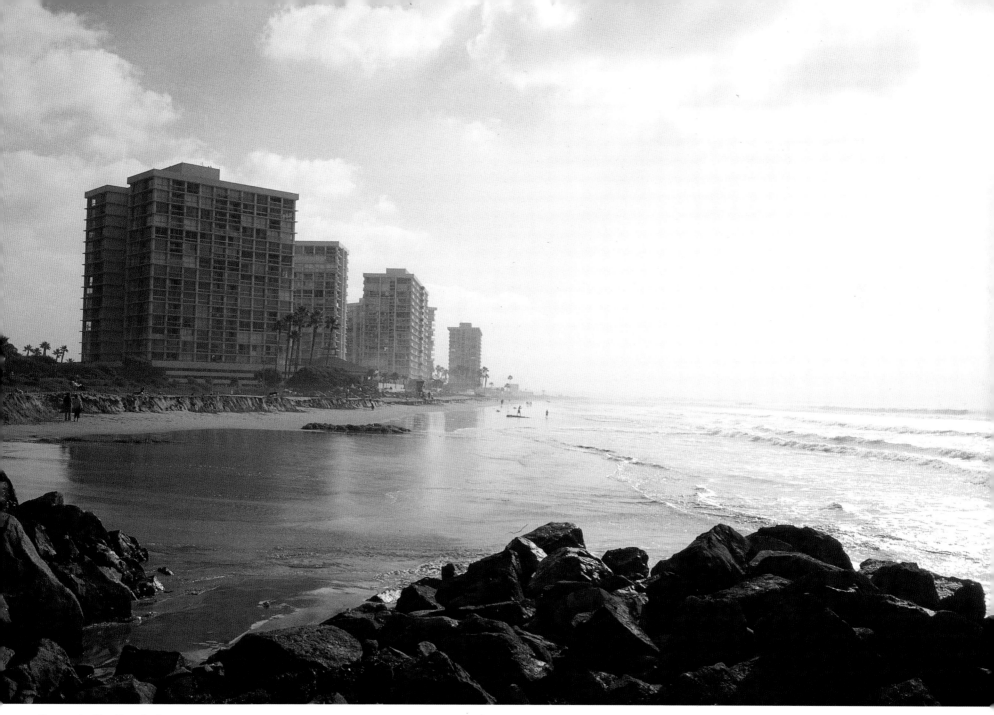

Coronado City Beach view.

Album Six:

Del Mar

What California town has a song written for it? Why Del Mar of course. Bing Crosby's song "Where the Turf Meets the Surf" was a tribute to Del Mar. The song is played today at the beginning of race day—and the song's title was even adopted by the City of Del Mar as its motto!

Del Mar is a beautiful resort beach town with a history of tourism stretching back to the 1880s. Theodore Loop, a railroad investor, and a wealthy rancher named Jacob Taylor recognized the development opportunities and envisioned a resort town for the rich and famous.[10] Today the city comprises only two square miles of coastal land, but it is one of the most desirable places to live in San Diego County.

What's in a Name?

Theodore Loop's wife, Ella, suggested the name Del Mar. She was inspired by the poem "The Flight on Paseo Del Mar."

Del Mar Resources

- *City of Del Mar*
www.delmar.ca.us
- *Del Mar Chamber of Commerce*
www.delmarchamber.com
- *Del Mar Fairgrounds*
www.sdfair.com
- *Del Mar Historical Society*
www.delmarhistoricalsociety.org/history.html
- *Del Mar Guide*
www.del-mar-guide.com

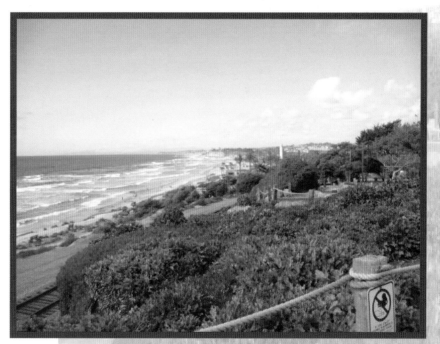

A view from the Cactus Garden.

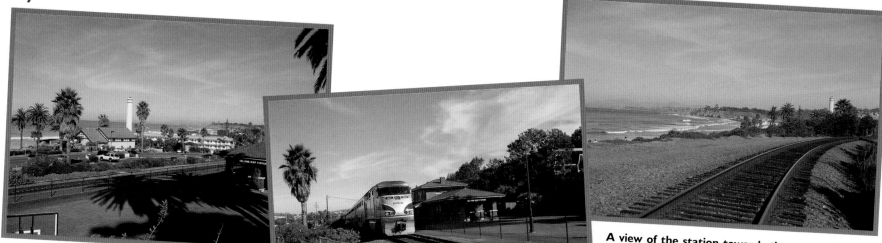

A view from the bluffs. The rail line seen in this shot was essential to the beginning history of settlement in Del Mar. In 1882, the Southern Railroad Company began its new route from San Diego to San Bernardino. Theodore Loop, who worked for the railroad, fell in love with what he called "the most attractive place on the entire coast."

Though the train no longer stops in Del Mar, the railroad continues to serve as an important link up and down the coast. Service ceased in 1995 when Solano Beach was chosen as the new commuter train station.

A view of the station towards the ocean. The first train came through Del Mar over 120 years ago. In 1910, after twenty-eight years of service, the tracks were moved to the bluffs.

An early morning bike ride. To the left is the Del Mar Flower Company stand at the corner of Camino Del Mar.

Quaint downtown Del Mar. The fountain by the Americana Restaurant on Camino Del Mar. Camino Del Mar is home to many restaurants, from incredibly delicious Brueggers Bagels to pizza at Del Mar Pizza.

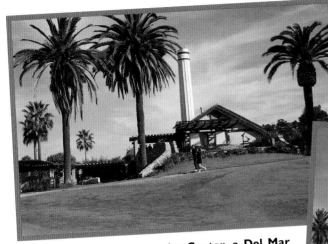

The Powerhouse Community Center, a Del Mar landmark, is perched on the bluff overlooking the white-sand beaches. Other uses have included a power plant and even a nightclub.

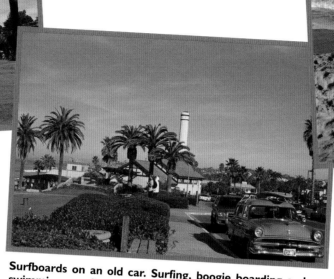

Surfboards on an old car. Surfing, boogie boarding and swimming are all popular pastimes at Del Mar.

A short climb down the sandstone bluffs leads to the water.

Waves breaking on the shore.

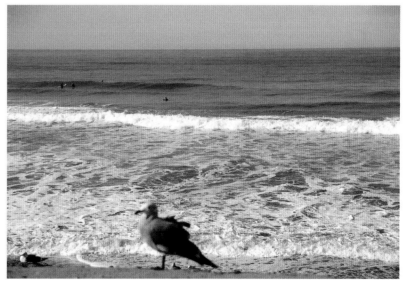

On the sand seagulls search for leftover crumbs from the sea and picnickers. In the distance a few surfers sit and wait for that 'perfect' wave.

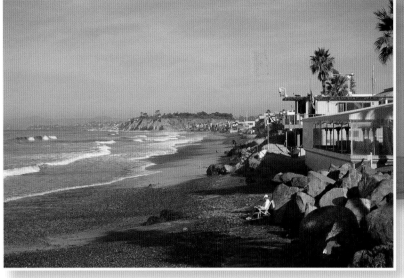

If you are not lucky enough to have a home with a view, it is not an uncommon site for people to bring lawn chairs and a good book down to the beach. What a backyard!

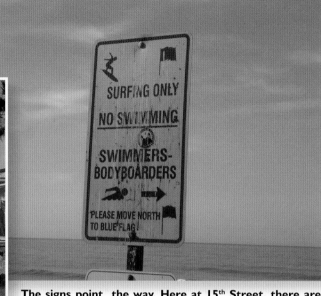

The signs point the way. Here at 15th Street, there are good reef breaks.

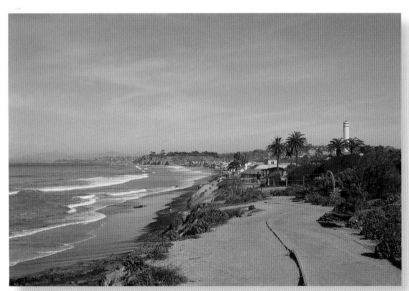

A view from the Cactus Garden towards Powerhouse Beach. The flat sandy beach is a great place to play.

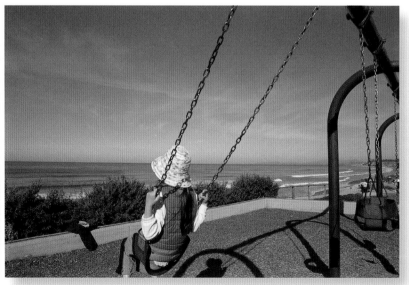

Swinging into the ocean. Powerhouse Park by Coast Boulevard is an idyllic playground situated next to a sandy beach and sparkling ocean. The park has swings, slides, picnic tables and a grassy area.

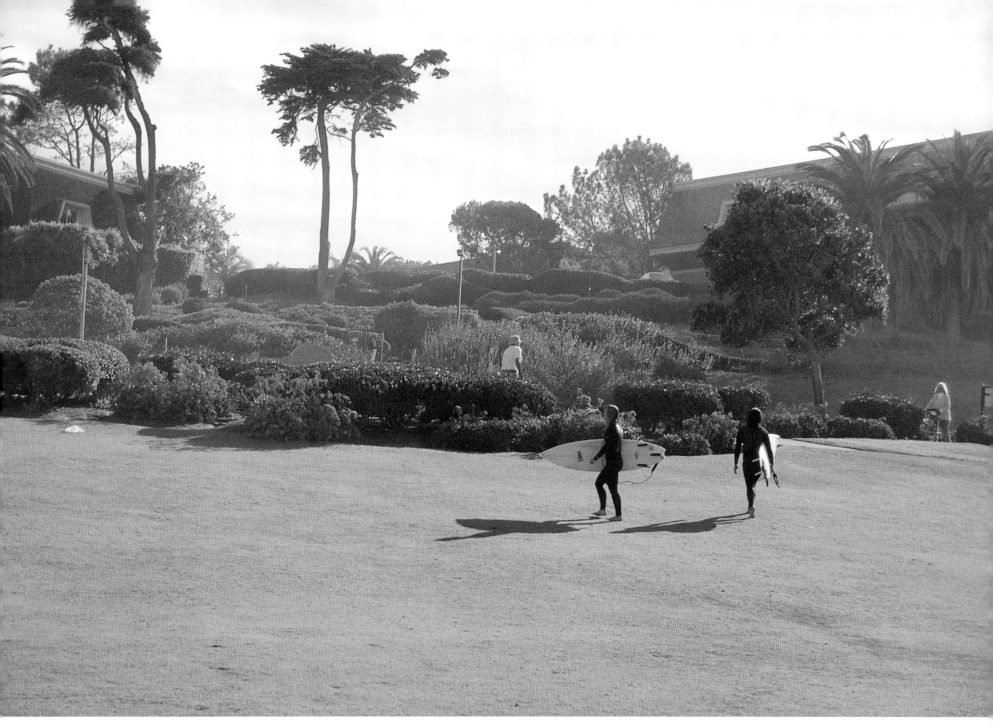

Two surfers at Seagrove Park and 15th Street Beach. Scattered over the manicured lawns of Seagrove Park are an assortment of belongings of those who have heeded the call of the waves. The Beach Boys 1960s hit 'Surfin USA' mentions Del Mar in the song.

Album Seven:

Carlsbad

Fifty acres of flowers with a sweet-pea maze, eighteen feet high giraffes built out of Lego's, three lagoons, a world famous spa and miles of beaches? Yes, Carlsbad is a gem of a town only thirty-five miles north of San Diego. Tourists flock to Carlsbad for swimming, surfing, fishing, diving, the world famous flower fields and Lego land. The city is also home to the famous La Costa Resort and Spa, The Four Seasons Resort and the only Arnold Palmer designed golf course in San Diego County.

With a quaint British seaside feeling, Carlsbad certainly lives up to its nickname 'the village by the sea.' The town's village slogan was adopted in the late 1970s. Though no fish and chip shops were spotted, there was an abundance of antique, touristy souvenir shops, small restaurants and pubs. If possible, park the car in downtown Carlsbad and wander around on foot. The beach itself is located along Carlsbad Boulevard at Ocean Street.

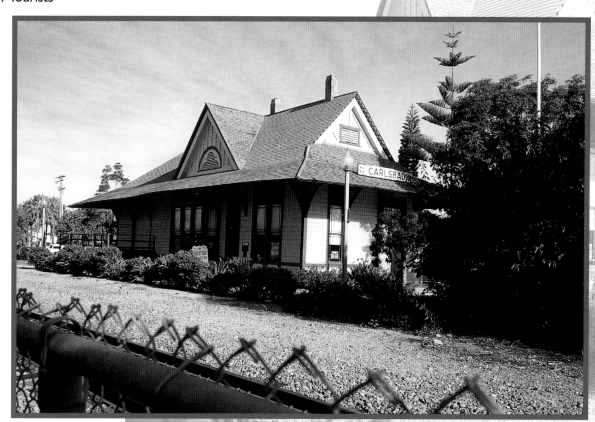

What's in a Name?

The community of Carlsbad is named for the Eighteenth Century Karlsbad Spa in the Czech Republic. The water was said to be chemically similar to the water of this spa.

The main street of Carlsbad has many charming gift shops.

A Hula girl welcomes visitors to this gift shop.

An early morning flower stall on State Street. As the flower fields are close by, you would expect to see beautiful flowers for sale in Carlsbad.

Bamby's Flowers stall sign.

Many antique stores line the streets of Carlsbad.

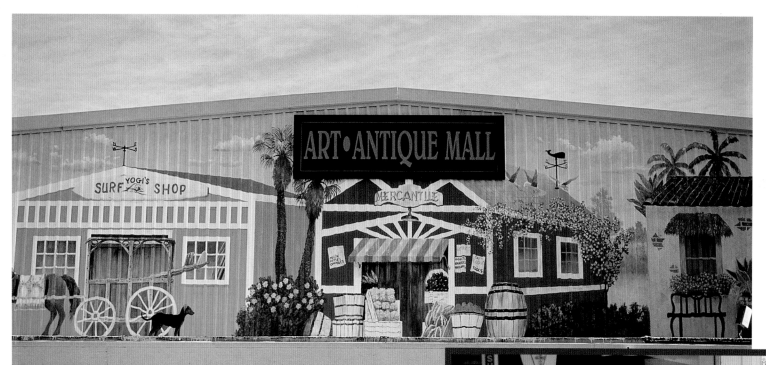

A mural on the art and antique mall on State Street.

A wrought iron chaise outside of an antique store.
Courtesy of KEY.

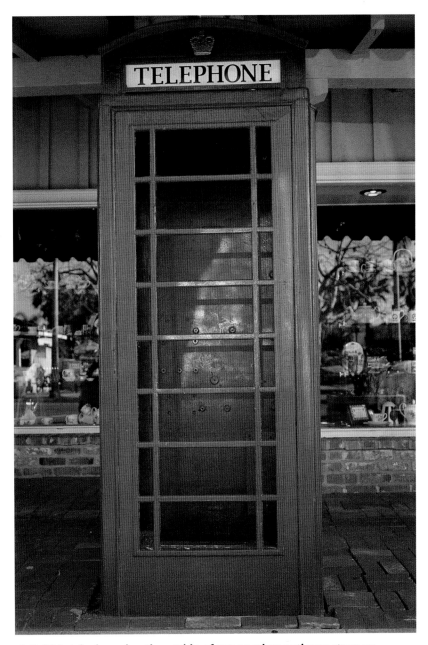

A British telephone booth outside of yet another antiques store on State Street.

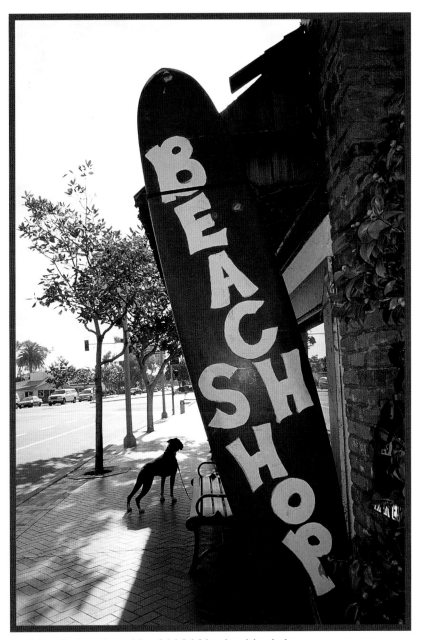

A beach shop sign with a faithful friend waiting below.

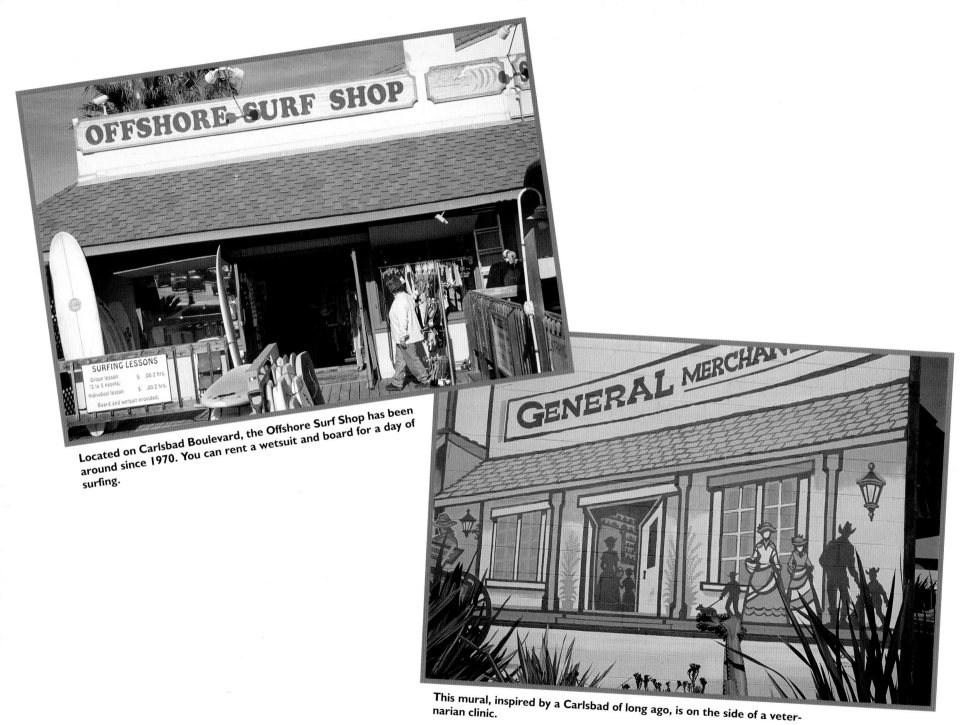

Located on Carlsbad Boulevard, the **Offshore Surf Shop** has been around since 1970. You can rent a wetsuit and board for a day of surfing.

This mural, inspired by a Carlsbad of long ago, is on the side of a veterinarian clinic.

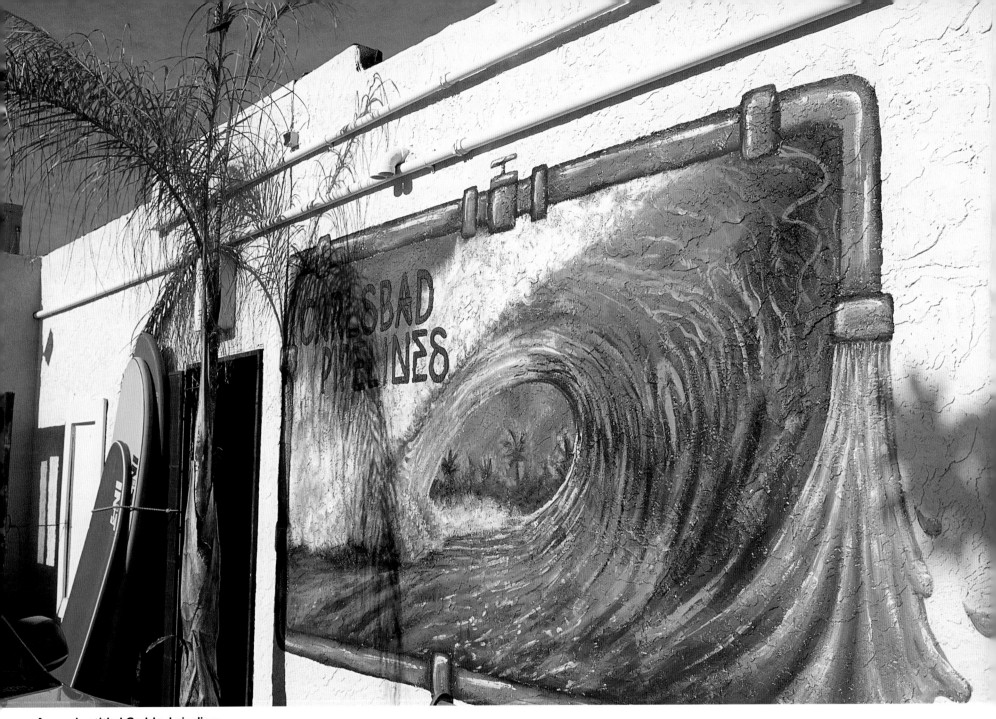

A mural entitled Carlsbad pipelines.

More sights

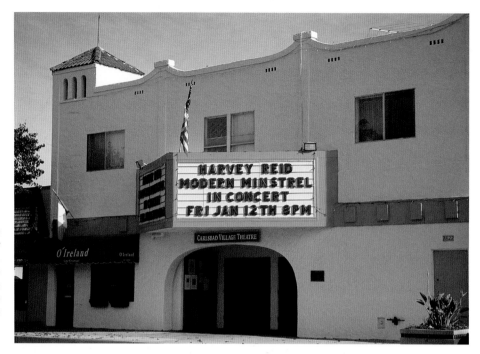

The Carlsbad Village Theater. The theater was built in 1927. It has been home to black and white movies, vaudeville productions, and live theater.

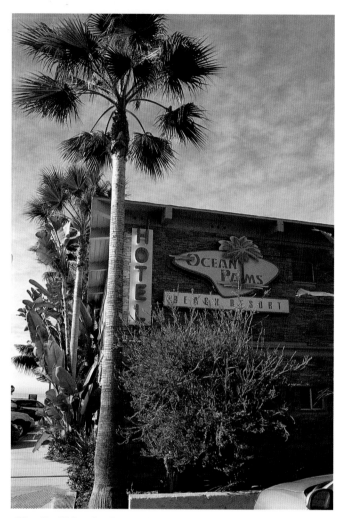

The Surf Motel—Ocean Palms.

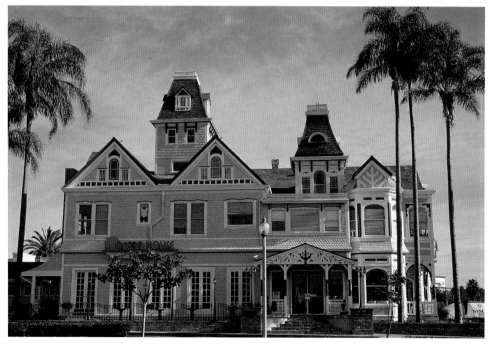

Carlsbad Village Street fairs are held the first Sundays in May and November—they're the largest single-day street fairs in California. Over 850 arts and crafts booths line the village streets with 80,000 people generally attending.

Restaurants

Fresh fruit on the main street.

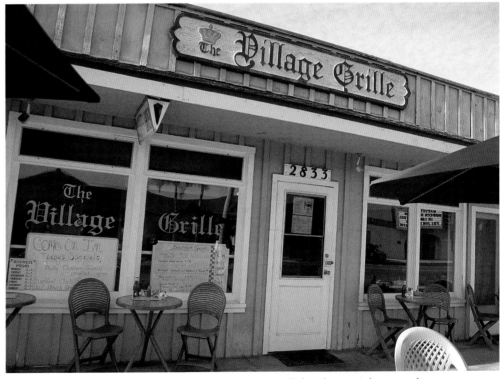

The Village Grille. According to a local newspaper poll, for the past six years the restaurant has had the best burgers.

A sandy welcome to the beach.

On The Beach

Carlsbad was named one of the top family beach destinations by travel writer, Emily Kaufman, 'The Travel Mom'. To preserve the natural beauty of Carlsbad, sand is brought in as the sea has slowly risen over thousands of years and the beach has inevitably narrowed.

Stroll along the beach by the mile-long Carlsbad Seawall. The seawall is located one block south of Carlsbad Village Drive and continues south for nearly a mile to Tamarack.

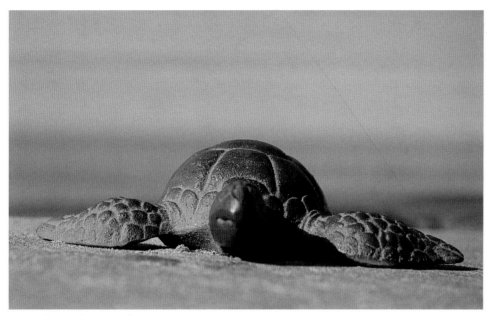

A turtle on the seawall.

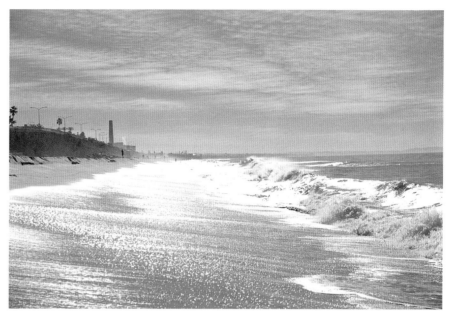

Glistening sand.

Waves.

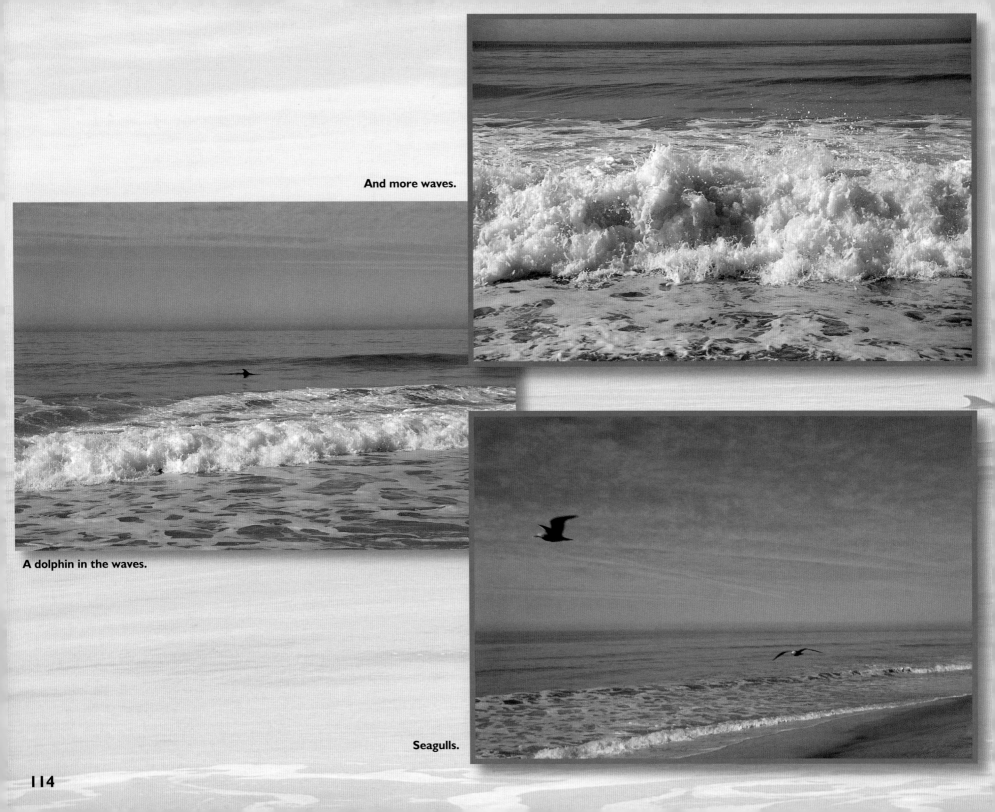

And more waves.

A dolphin in the waves.

Seagulls.

114

Sunbathing.

Taking in the view. Looking towards beachside condos in the direction of Oceanside.

End of the day.

Just the two of us.

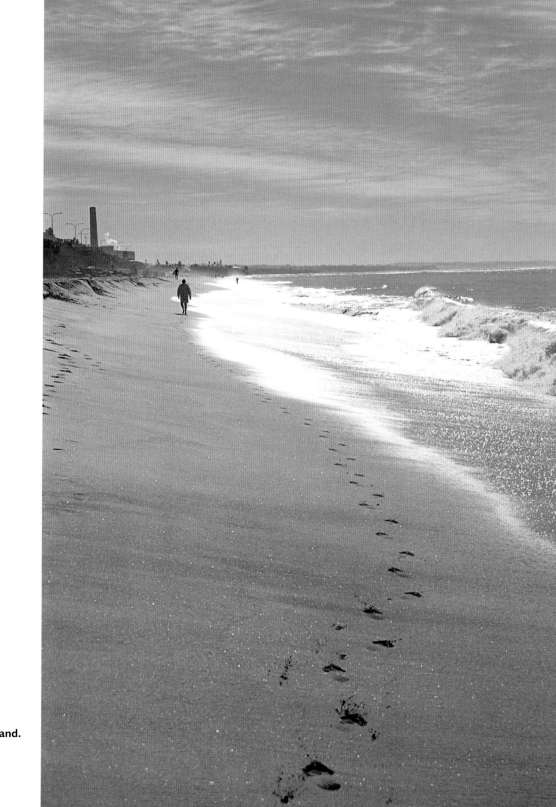

Footsteps in the sand.

Carlsbad Resources

- *Carlsbad Historical Society*
 www.carlsbadhistoricalsociety.com
- *Carlsbad Tourism Site*
 www.visitcarlsbad.com
- *Carlsbad Chamber of Commerce*
 www.carlsbad.org
- *City of Carlsbad*
 www.carlsbadca.gov
- *Legoland*
 www.legoland.com
- *The Flower Fields at Carlsbad Ranch*
 www.theflowerfields.com

A Christmas display at the outlet.

Carlsbad Outlet Center. When you need a rest from the sand, shopping is close at hand.

Ocean and sand.

The fountain at **State** and **Grand** streets. Beginning in the early 1980s a program of beautification and redevelopment was initiated.

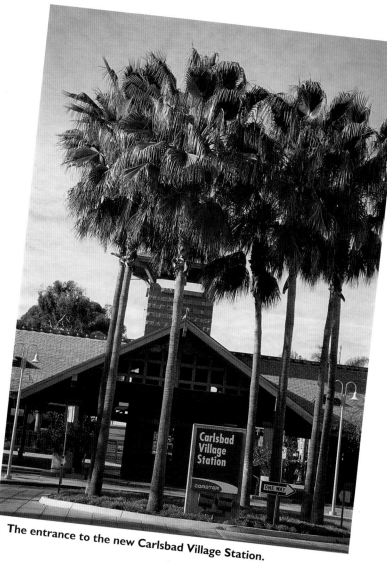

The entrance to the new Carlsbad Village Station.

San Diego Visitor Resources

There is always something to do in San Diego...

- City of San Diego
www.sandiego.gov
- City of San Diego Parks and Recreation
www.sandiego.gov/parkandrecreation
- San Diego Convention Center
www.sdccc.org
- San Diego Historical Society
www.sandiegohistory.org
- San Diego Convention Center &
Visitors Bureau
www.sandiego.org
- Surf San Diego
www.surfingsandiego.com

San Diego Museums

- *Balboa Park Museums*
www.balboapark.org
- *California Surf Museum*
www.surfmuseum.org
- *Junipero Serra Museum*
*www.sandiegohistory.org/mainpages/
locate4.htm*
- *Museum of Contemporary Art*
www.mcasd.org

San Diego Historical Sites

- *Cabrillo National Monument*
www.nps.gov/cabr/
- *California Missions*
www.californiamissions.com
- *Gaslamp Quarter*
www.gaslamp.org
- *Old Town State Park*
*http://parks.ca.gov/default.asp?
page-id=663*

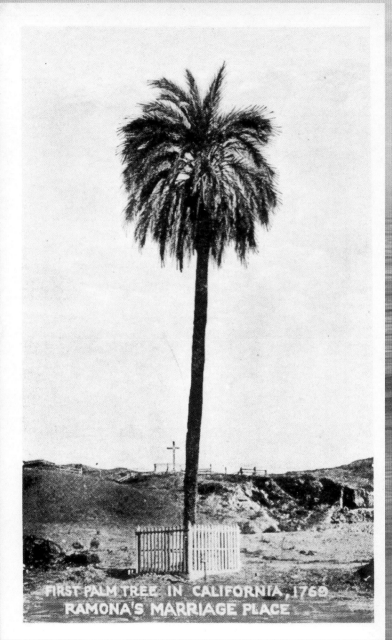

First Palm Tree. Vintage miniature postcard, c.1920s.

THE GARDEN
RAMONA'S MARRIAGE PLACE SAN DIEGO CALIFORNIA

Old Town San Diego. *Ramona's Marriage Place,* Helen Hunt Jackson's romantic novel, was set here. The adobe was built in 1827. Vintage miniature postcard, c.1920s.

FREMONT MONUMENT, FIRST AMERICAN FLAG IN SO. CALIF. RAISED HERE, RAMONA'S MARRIAGE PLACE

The First American Flag. Vintage miniature postcard, c.1920s.

CALIFORNIA'S FIRST MISSION BELLS, RAMONA'S MARRIAGE PLACE

The Mission Bells. Vintage miniature postcard, c.1920s.

121

San Diego Amusements

- *San Diego's Wild Animal Park*
www.sandiegozoo.org
- *San Diego Zoo*
www.sandiegozoo.org
- *Sea World*
www.seaworld.com

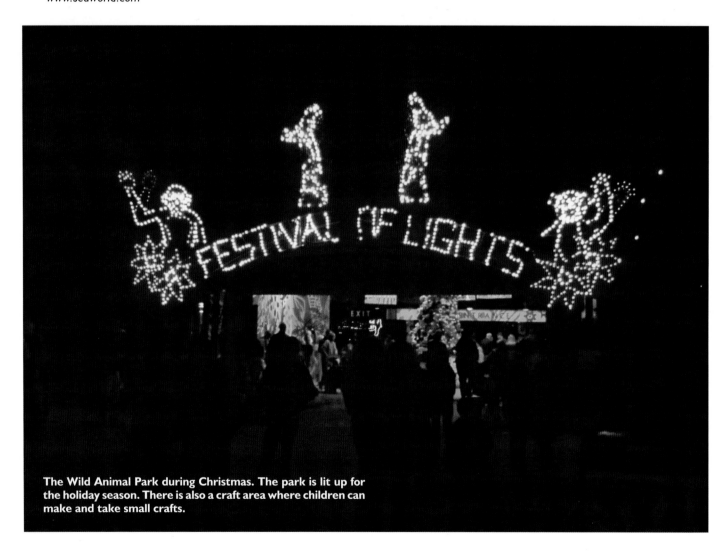

The Wild Animal Park during Christmas. The park is lit up for the holiday season. There is also a craft area where children can make and take small crafts.

San Diego County Beaches

Beacon's Beach
Black's Beach
Boneyard Beach
Border Field State Park
Cardiff State Beach
Carlsbad City Beach
Carlsbad State Beach
Children's Pool Beach
Coronado Shores Beach
Coronado City Beach
D Street Viewpoint
Del Mar City Beach
Encinitas Beach
Fletcher Cove Park
Harbor Beach
La Jolla Cove
La Jolla Shores Beach
La Jolla Strand Park
Imperial Beach
Marine Street Beach
Mission Beach
Moonlight Beach
Ocean Beach City Beach
Oceanside City Beach
Pacific Beach
Ponto Beach
San Elijo State Beach
Seascape Shores
Silver Strand State Beach
Stone Steps Beach
South Carlsbad State Beach
South Oceanside Beach
San Onofre State Beach
Swami's
Tide Beach Park
Tourmaline Surfing Park
Torrey Pines State Beach
Windansea Beach

The Flamingo Lagoon has over seventy residents.

Bibliography

Dibona, Joanne. "San Diego Tourism Outlook for the Remaining Year." San Diego Convention & Visitors Bureau. Dec. 5, 2006 <www.sandiego.org/article/Members/254>

Held, Ruth Varney. *Beach Town: Early Days in Ocean Beach.* San Diego, California: Duke & Freeth, 1976.

Lockwood, Herbert W. "Camping on the Strand-Summertime Invasions of Coronados Beachfront Go Back to the Early 1900's." *San Diego Metro.* May 1998. <http://www.sandiegometro.com/1998/may/skeleton.html>

Mills, James R. *San Diego - Where California Began.* San Diego, Califronia: San Diego Historical Society, 1985.

Ray, Brandes, and Katherine Carlin. *Coronado: The Enchanted Island.* Coronado, California: Coronado Historical Association, 1998.

Reinder, Reint. "Branding the Southern California Lifestyle." *San Diego Source.* July 28, 2005. <www.sddt.com/commentary/article.cfm?CommentaryID=17&SourceCode=20050728tza>

Schnebelen Gutierrez, Susan. *Windows on the Past: an Illustrated History of Carlsbad, California.* Virginia Beach, Virginia: Donning Publisher's Company, 2002.

Smythe, William E. "History of San Diego 1542-1908." San Diego, California: San Diego Historical Society, Nov-Dec. 2006 <http://www.sandiegohistory.org/books/smythe/>

A winter garden by Children's Pool.

The Star of India. The ship was built in 1863 making it the world's oldest active sailing-ship. It is said that ghosts haunt the decks and cabins below.

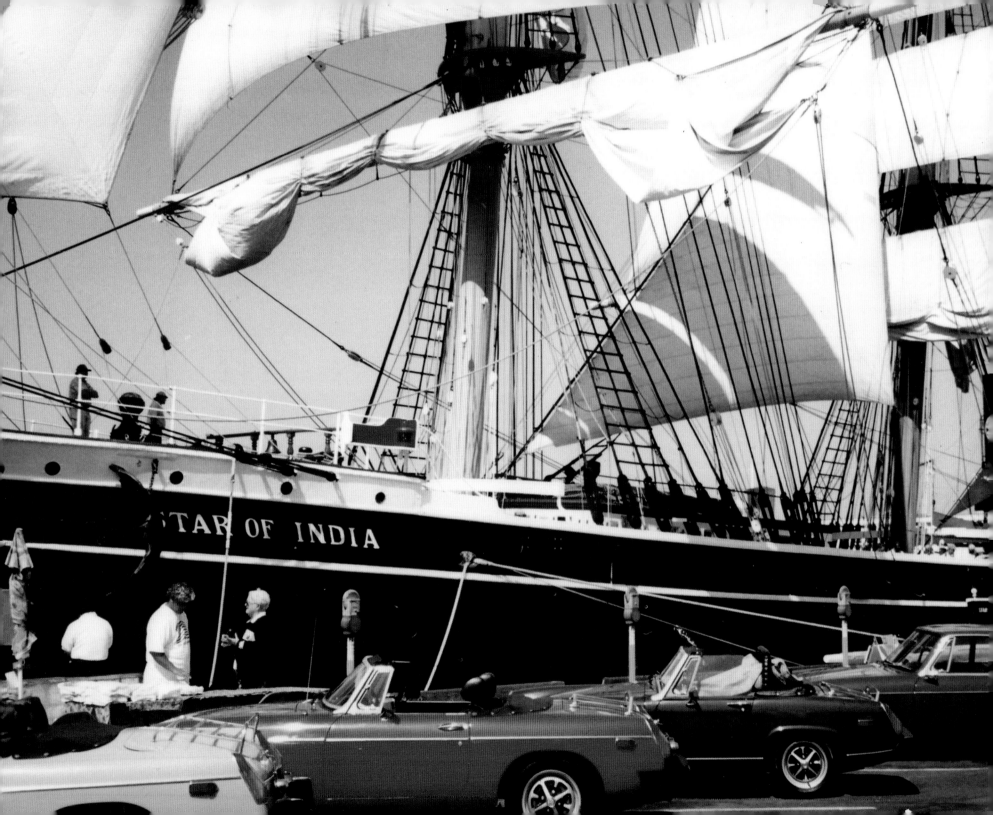

Footnotes

1. Amero, Richard. "Panama-California Exposition ~ San Diego~ 1915-1916." San Diego Historical Society, 2003. <www.sandiegohistory.org/pancal/sd-expo33.html>.

2. Amero, Richard. "Panama-California Exposition ~ San Diego~ 1915-1916." San Diego Historical Society, 2003. <http://www.sandiegohistory.org/calpac/35expoh5.htm>.

3. "Balboa Park History." Balboa Park. 2007. <www.balboapark.org/info/history.php>.

4. Lehmann, Jeffrey. "An Intimate History of a San Diego Beach Town, La Jolla." PBS. January 7, 2007. <www.pbs.org/weekendexplorer/destinations/california/sandiego/lajolla/history.html>.

5. Hlebica, Joe. "Scripps Family." Scripps Institution of Oceanography, 2002. <www.scripps100.ucsd.edu/features/scrippsfam/index.html>.

6. "History of PB." Pacific Beach, 2003. <www.pacificbeach.org/history/index.html>.

7. Bays Locker, Zelma. "The Journal of San Diego History Spring 1976, Volume 26, Number 2." San Diego History, 1976. <www.sandiegohistory.org/journal/76spring/izard.html>.

8. San Diego Community Profile: Mission Beach." The City of San Diego, 2005. <www.sandiego.gov/planning/community/profiles/missionbeach/index.html>.

9. "Mission Bay Park." The City of San Diego, 2005. <www.sandiego.gov/park-and-recreation/parks/missionbay/index.html>.

10. "Olde Del Mar." Del Mar Historical Society, 2007. <http://www.delmarhistoricalsociety.org/history.html>.

Vintage photograph c.1940s.

Index